GET IN THE GAME

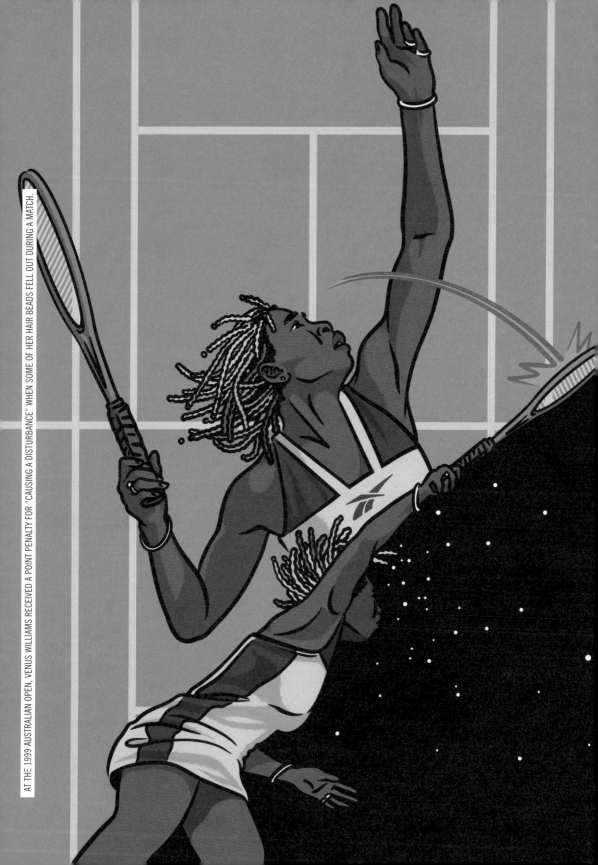

AT THE 1999 AUSTRALIAN OPEN, VENUS WILLIAMS RECEIVED A POINT PENALTY FOR "CAUSING A DISTURBANCE" WHEN SOME OF HER HAIR BEADS FELL OUT DURING A MATCH.

GET IN THE GAME: SPORTS, ART, CULTURE

Edited by Jennifer Dunlop Fletcher, Seph Rodney & Katy Siegel

San Francisco Museum of Modern Art in association with Tra Publishing, Miami

You can change society by changing people's perceptions and understandings of the games they play.

–Harry Edwards

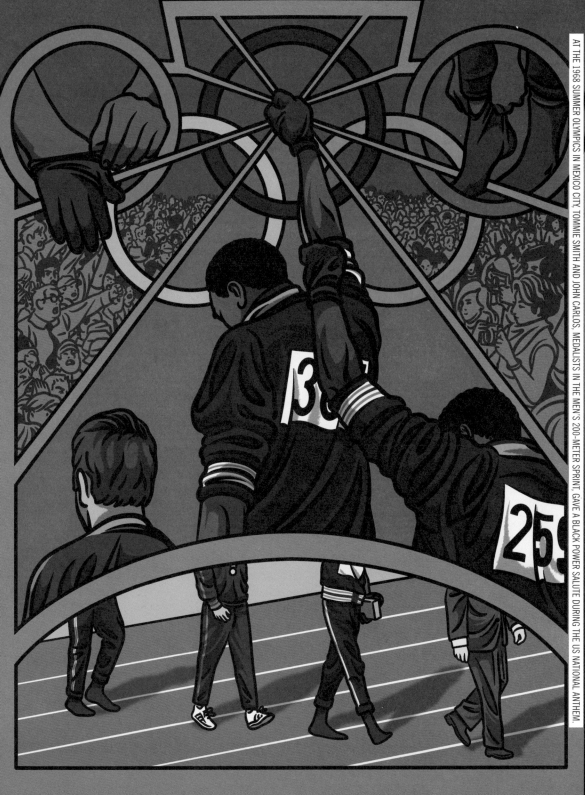

AT THE 1968 SUMMER OLYMPICS IN MEXICO CITY, TOMMIE SMITH AND JOHN CARLOS, MEDALISTS IN THE MEN'S 200-METER SPRINT, GAVE A BLACK POWER SALUTE DURING THE US NATIONAL ANTHEM.

CONTENTS

DIALOGUES

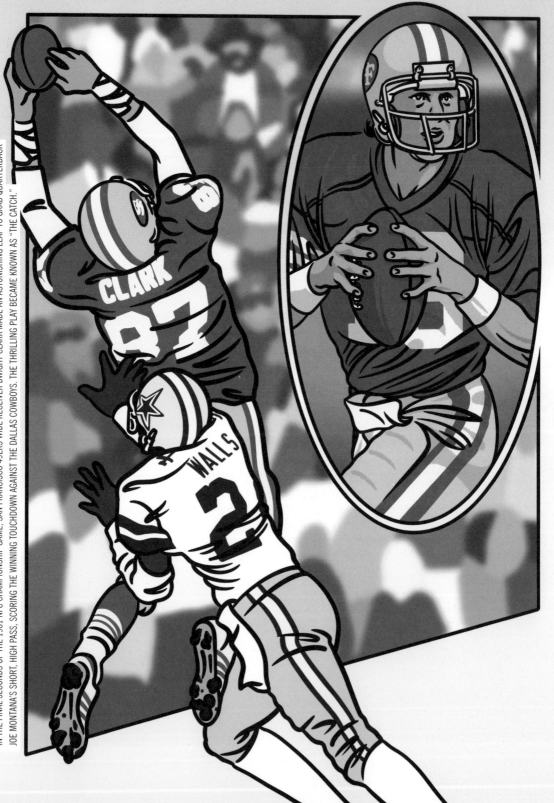

IN THE FINAL SECONDS OF THE 1981 NFC CHAMPIONSHIP GAME, SAN FRANCISCO 49ERS WIDE RECEIVER DWIGHT CLARK MADE AN ASTONISHING LEAP TO GRAB QUARTERBACK JOE MONTANA'S SHORT, HIGH PASS, SCORING THE WINNING TOUCHDOWN AGAINST THE DALLAS COWBOYS. THE THRILLING PLAY BECAME KNOWN AS "THE CATCH."

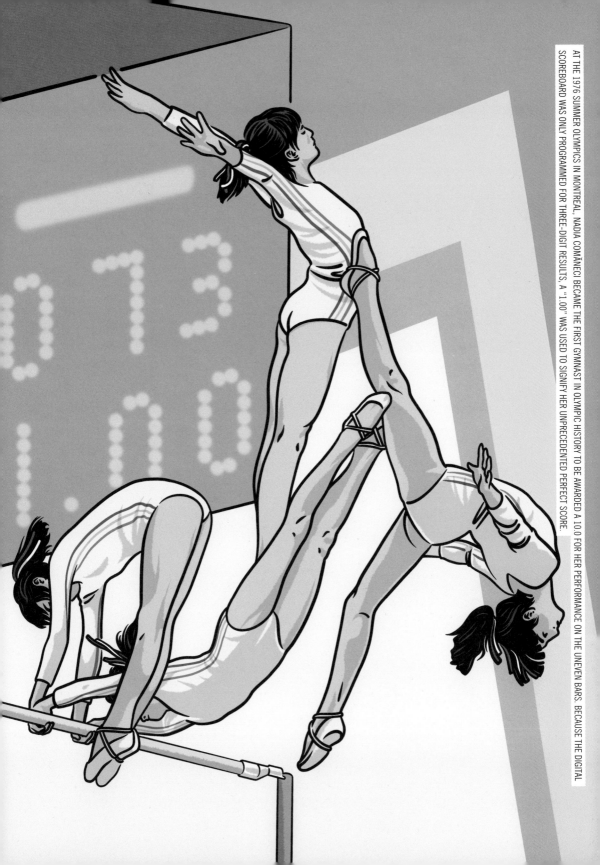

AT THE 1976 SUMMER OLYMPICS IN MONTREAL, NADIA COMĂNECI BECAME THE FIRST GYMNAST IN OLYMPIC HISTORY TO BE AWARDED A 10.0 FOR HER PERFORMANCE ON THE UNEVEN BARS. BECAUSE THE DIGITAL SCOREBOARD WAS ONLY PROGRAMMED FOR THREE-DIGIT RESULTS, A "1.00" WAS USED TO SIGNIFY HER UNPRECEDENTED PERFECT SCORE.

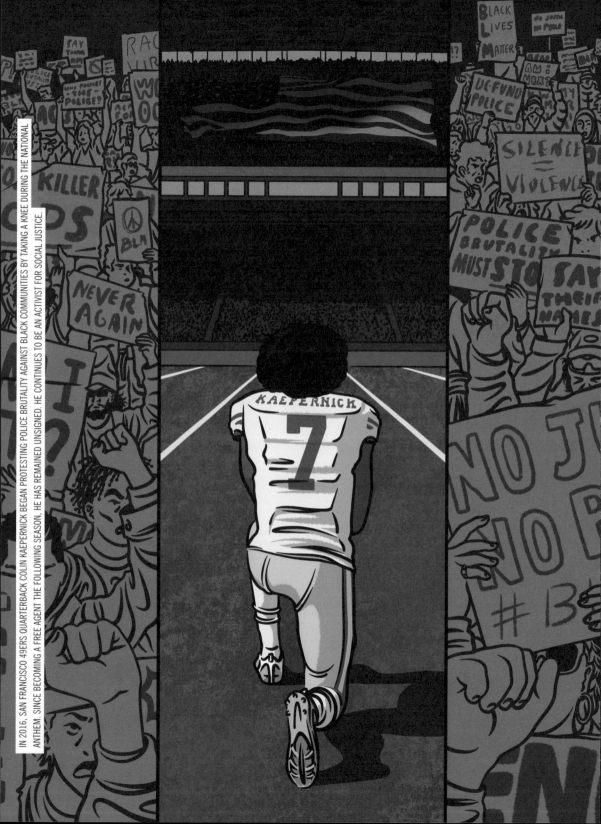

IN 2016, SAN FRANCISCO 49ERS QUARTERBACK COLIN KAEPERNICK BEGAN PROTESTING POLICE BRUTALITY AGAINST BLACK COMMUNITIES BY TAKING A KNEE DURING THE NATIONAL ANTHEM. SINCE BECOMING A FREE AGENT THE FOLLOWING SEASON, HE HAS REMAINED UNSIGNED. HE CONTINUES TO BE AN ACTIVIST FOR SOCIAL JUSTICE.

LAY IT ON THE LINE

Megan Rapinoe

SPORTS GIVE US AN OPPORTUNITY to see people try their absolute best and be great a lot of the time, but whenever there's competition there's also fallibility and failure. That is part of what makes a match so beautiful and inspiring—watching people be vulnerable and really lay it all out there. As athletes, we're giving everything we can on the field. It's exciting. There are mental and emotional dimensions to it, along with the physical, and anyone who has played any kind of sport can connect with that. Yet there's something particularly extraordinary about watching a seemingly ordinary fellow human step onto the field and do something that most people could never do.

Having just retired from women's professional soccer in 2023, I've been thinking about what it means to be an athlete, and how that changed for me over the course of my career. At the core it stayed the same: I got to play my sport and run around for a living, and the goal was similar to what it was when I was five years old, or twelve, or seventeen. But the growth of women's sports generally

Everyone can learn something from athletes and artists about laying it all on the line, whatever their goal may be. Find something that inspires you to fight and to live a more expansive life, something that you want to keep coming back to even though it makes you uncomfortable and requires you to put all of yourself out there.

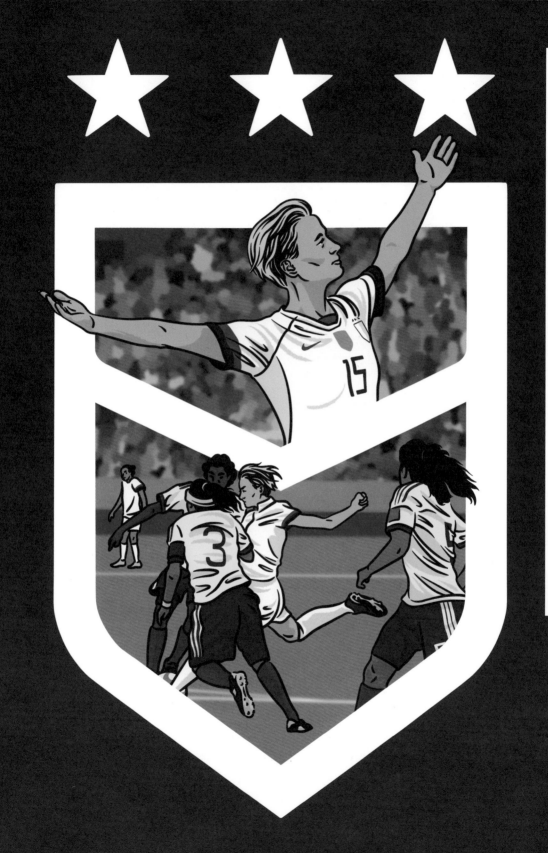

AFTER SCORING IN THE 2019 FIFA WOMEN'S WORLD CUP QUARTERFINALS IN PARIS, MEGAN RAPINOE JOGGED TO THE SIDELINES AND STRETCHED OUT HER ARMS IN VICTORY, A GESTURE THAT PROCLAIMED THE JOYFUL EXCELLENCE OF WOMEN ATHLETES AMID DEBATES ABOUT EQUAL PAY. THE WIDELY PHOTOGRAPHED MOMENT QUICKLY WENT VIRAL.

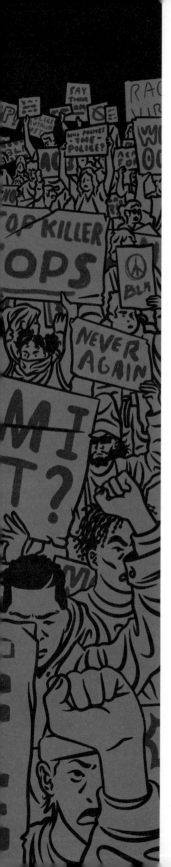

and the rising interest in women's soccer, both globally and within the US, dramatically increased my platform. I became one of the most popular players on one of the most popular teams, and a much greater sense of responsibility came with that. Within sports, athletes are asked to be our very best *all the time*, and I extended that sense of responsibility off-field as well. Over the course of my career, as I grew as a person and became more politically engaged, I increasingly coupled my focus on soccer with my efforts to use my platform as an athlete to effect change. For me, there was no point in having such celebrity if I wasn't going to use it for good. Pushing the bounds of what it means to be an athlete and embracing the potential for broader cultural impact was part of what kept me motivated and inspired.

I always wanted to be the best player I could be, and I liked being part of a successful team. But in sports, as in life, you don't get to win all of the time. When I was growing up, and certainly early in my career, I lost a lot. I think sometimes this gets overlooked because as part of the US women's national soccer team, particularly during the last six or seven years, there were so many wins and so much success—on and off the field. But just looking to the wins really isn't life. And although there is something incredibly beautiful about watching someone bare it all for this thing they really want, there is much to be learned from the humanity of falling short and not achieving your goal but still being okay. I think the point of life is not to win or lose, but to try. To really put it all out there and just go for it. So I take the losses with as much of an open heart as I do the wins—there are amazing aspects to both.

I think that our humanity is part of what positions athletes well to lead change. I see myself as a female athlete and a gay athlete. Like all individuals, athletes are always at the intersections of experience: whether someone is a trans athlete, a Black athlete, or an immigrant, whether they're a mother or have a family. Sports is really one of the only meritocracies: anyone from any background, if you're that good, you're going to be competing at a high level. There's something so inherently diverse about sports. Don't get me wrong—there's still plenty of inequality, racism, sexism, and homophobia, but the sports world just feels much more accessible than society does in a lot of ways. I've come to recognize that even

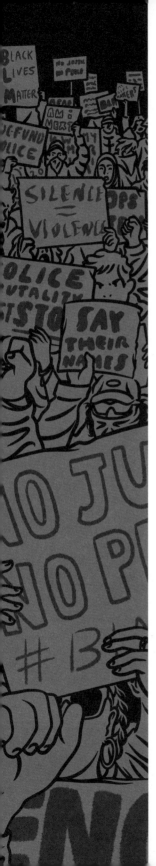

at the highest levels of professional sports, athletes not only have a celebrity platform but also share many of the experiences and concerns of everyone else. And having fought through so much to get where we are, we are keenly aware of where the inequities are, and we want to use our cultural position in ways that have an impact.

Get in the Game highlights the capacity that both art and sports have to help us think through questions of equity and social justice, and to spark moments of creativity and shared humanity. In these pages you will see many examples of affinity between athletes and artists. Both have special talents, and of course also have to work hard and bring a singular focus and a mental, physical, and even spiritual commitment to refining their craft. I hear athletes talk a lot about their craft, and I don't think that's an accident. It is a direct line to being an artist, to creating something beautiful, something new. We are doing work we love that requires us to commit and to share our whole selves—talent, passion, struggles, and vulnerabilities all in one. But this spirit of fully engaging, of bringing your whole being to bear on pushing for the outcomes you want to see in the world, isn't limited to those with elite athletic or artistic talent. Everyone can learn something from athletes and artists about laying it all on the line, whatever their goal may be. Find something that inspires you to fight and to live a more expansive life, something that you want to keep coming back to even though it makes you uncomfortable and requires you to put all of yourself out there. Lay it on the line.

Megan Rapinoe is a two-time Women's World Cup champion and an Olympic gold medalist, as well as a prominent advocate for LGBTQI+ rights, gender pay equality, and racial justice. A vocal leader in every aspect of her life, she helped lead the US women's national team to the 2019 Women's World Cup championship. She has been named one of Time's 100 Most Influential People and is a recipient of a 2022 Presidential Medal of Freedom.

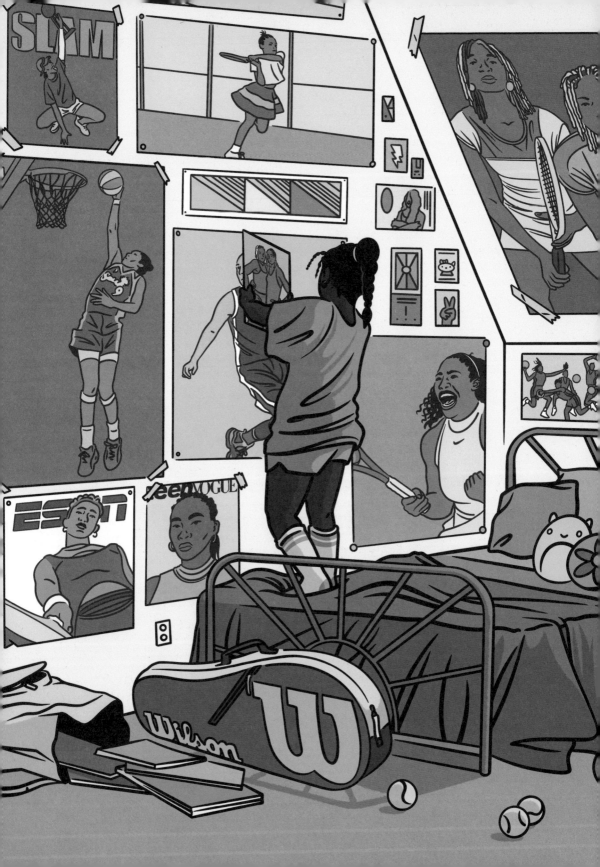

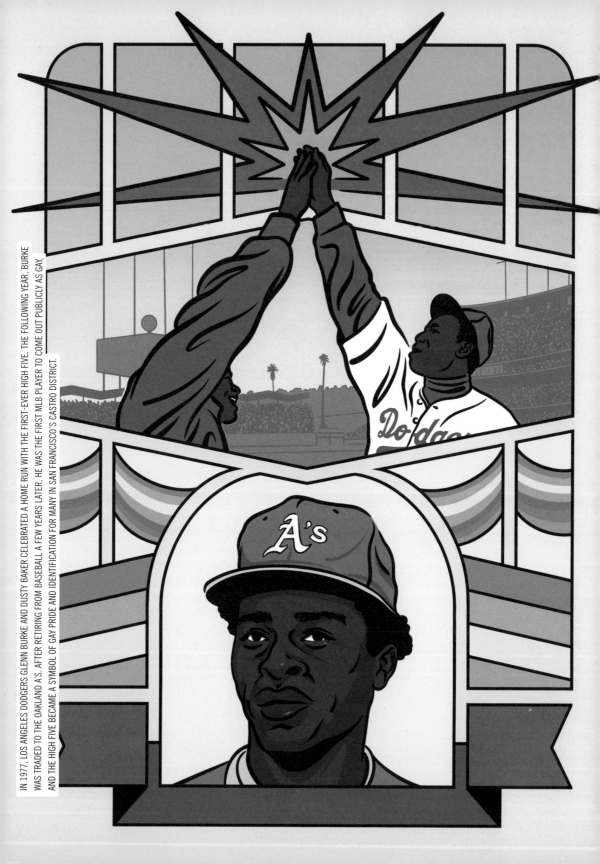

IN 1977, LOS ANGELES DODGERS GLENN BURKE AND DUSTY BAKER CELEBRATED A HOME RUN WITH THE FIRST-EVER HIGH FIVE. THE FOLLOWING YEAR, BURKE WAS TRADED TO THE OAKLAND A'S. AFTER RETIRING FROM BASEBALL A FEW YEARS LATER, HE WAS THE FIRST MLB PLAYER TO COME OUT PUBLICLY AS GAY, AND THE HIGH FIVE BECAME A SYMBOL OF GAY PRIDE AND IDENTIFICATION FOR MANY IN SAN FRANCISCO'S CASTRO DISTRICT.

THE GAMES PEOPLE PLAY

Jennifer Dunlop Fletcher & Katy Siegel

GET IN THE GAME: SPORTS, ART, CULTURE explores the intersections of art and sports and the ways that they reflect and shape contemporary debates about physical experience, identity, and society. As with other forms of cultural expression, art and sports have become serious business, rewarding the artists and athletes who perform with the most discipline, brilliance, grace, and power, and also putting enormous pressure on them. Despite this professionalization, the two realms share a common root in play and games. Philosophers from Aristotle to Friedrich Schiller have defined play as something we do not out of necessity but for love: freely undertaken, it allows us to shed the constraints of everyday survival. Play becomes a game or sport when you add rules and competition, rolling back the element of freedom and replacing it with a commonly held structure defined by boundaries, regulations, and obstacles to overcome. Athletic

Ultimately, both art and sports are made possible by an audience's collective belief. Without that engagement, activities such as moving a ball across artificial grass using only our feet or applying liquid color to canvas with a brush would feel absurd.

games unfold in service of a predetermined goal—for example, scoring touchdowns—and ultimately produce winners and losers. Navigating the art world too can be viewed as a kind of game, with its own stakes, strategies, and competition.

The role of spectator is neither neutral nor passive. Ultimately, both art and sports are made possible by an audience's collective belief. Without that engagement, activities like moving a ball across artificial grass using only our feet or applying liquid color to canvas with a brush would feel absurd. Athletes, artists, and their audiences decide to believe that doing these things matters, and to observe the rules and care deeply about the results. We also have to trust in the fairness and sanctity of the game, which is why uncertainty of the outcome is key, why cheating scandals remain so shocking, why we don't want special equipment to determine who wins, and why advantages of connections and class create controversy. We want to believe that sheer talent, skill, love, and discipline can overcome disadvantage and discrimination, and that the dedicated underdog can triumph. From an early age, many artists and athletes with even a little talent are encouraged to hone their skills and believe they can become the best. Sports fans do their part by remaining passionately loyal to their favorites. This is why so many people speak of both art and sports in almost religious terms, as transcendent realms to which their practitioners are wholly committed, around which entire ecosystems revolve, and whose rules and rituals they

faithfully enact. When we walk into a contemporary professional sports arena, the lights, sounds, and scale of the spectacle amplify the feeling that we have moved into another sphere; when we walk into a museum, the awe-inspiring architecture, reverent quiet, and striking works of art aim to transport us.

Art and sports celebrate the human mind and body, and they reward genius, the extraordinary individual who is simply better than everyone else. They each have their respective GOATS, and arguing about the pantheon is a kind of bracket played in both fields: Picasso versus Matisse, Jordan versus LeBron. This can be a little trickier in art, where skill is harder to measure, but both fields celebrate the ones who rise above the rest. At a press conference on NBC Sports in 2021, basketball player Juan Toscano-Anderson said of his Warriors teammate Steph Curry, "I love this game for what it is. It's an art, and he's like the Picasso of our time." The artistic analogy is particularly apt in this case: Curry's greatest skills aren't his reach or his speed but his unmatched hand-eye coordination and the ability to see the whole court. He has opened new paths and set new standards and, like Picasso, he is known for his versatility. Artistic and athletic techniques were paired again in a *Wall Street Journal* article about that year's Super Bowl match-up between Kansas City Chiefs quarterback Patrick Mahomes and Tampa Buccaneers quarterback Tom Brady: "Mahomes's pass locations look like a Jackson Pollock: there are dots splattered all over the field behind the line scrimmage. Brady, on the other hand, just dumps a bucket of paint in one central location."

The comparison of Mahomes to Pollock draws out the artistry of his creative, free-form quarterbacking. While great players succeed according to the predetermined rules, they are often celebrated for breaking or at least bending those rules both on and off the field, reshaping the game and society more broadly. Artists often look to

Much of the cultural power of sports and art—and athletes and artists—comes from the fact that although they offer temporary escape, neither truly stands apart from society. They sharply mirror the ways America values money, fame, and success, and they reflect common biases around race, gender, sexuality, and class.

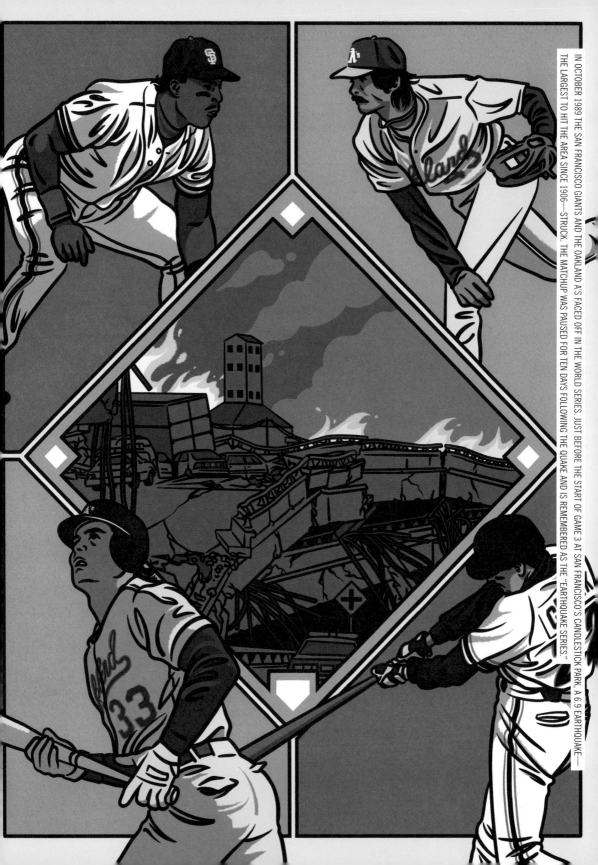

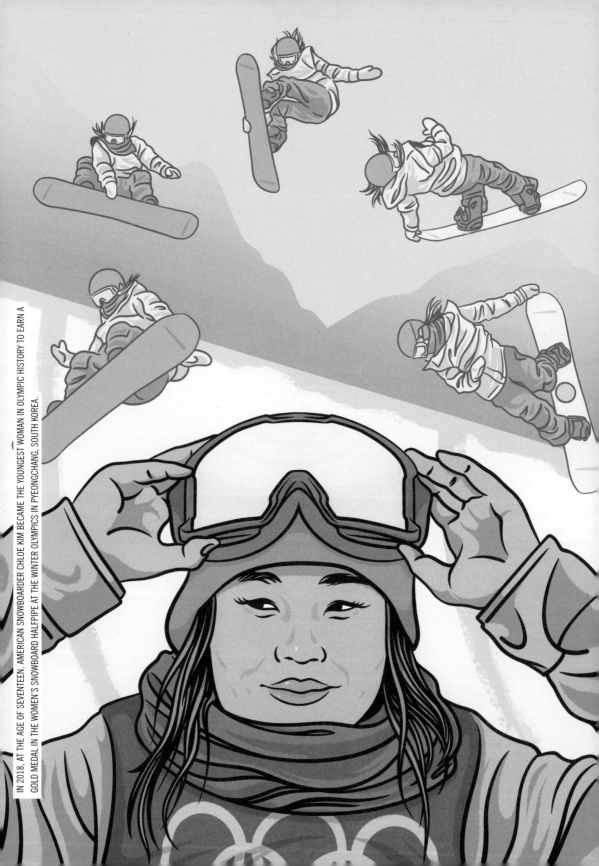

IN 2018, AT THE AGE OF SEVENTEEN, AMERICAN SNOWBOARDER CHLOE KIM BECAME THE YOUNGEST WOMAN IN OLYMPIC HISTORY TO EARN A GOLD MEDAL IN THE WOMEN'S SNOWBOARD HALFPIPE AT THE WINTER OLYMPICS IN PYEONGCHANG, SOUTH KOREA.

overturn the status quo, but there are few inherent restrictions on how to make art. In contrast, the established rules of a sport are essential for ensuring fairness and stability, and for protecting the covenant of belief between players and spectators. In instances of cheating or doping scandals, breaching the rules damages the game and the trust between players and fans. Yet both on and off the field it sometimes becomes necessary to drive social change by challenging the status quo. In 1967, Kathrine Switzer ran the Boston Marathon, rejecting a decades-long all-male tradition in the face of sometimes violent pushback; five years later, Congress enacted the Title IX legislation barring discrimination on the basis of sex, gender identity, and sexual orientation, leading to increased collegiate and professional sports opportunities for women. Progress is never static: today, those same policies can be restrictive for nonbinary athletes, and gender continues to be an issue that is policed and debated. When an athlete is in demand—by sports franchises, advertisers, and fans—they have the power to question or even break rules or norms that hinder participation, equality, or social progress. When track star Alysia Montaño's decision to run while pregnant threw her endorsements into question, she fought back, ultimately changing Nike's maternity policy as well as ideas about what women (and mothers) could do.

Much of the cultural power of sports and art—and athletes and artists—comes from the fact that although they offer temporary escape, neither truly stands apart from society. They sharply mirror the ways America values money, fame, and success, and they reflect common biases around race, gender, sexuality, and class. The playing field is never level. Most obviously, wealthy people are free to pursue physical excellence as an end in itself, while for working-class people, organized sports, which often come with a considerable physical toll, can be one of the few paths to financial

stability. In both sports and art, women and people of color have excelled, giving the lie to racist and sexist denigration. And many athletes—including Willie Mays, Althea Gibson, Muhammad Ali, Kathrine Switzer, Billie Jean King, Florence Griffith Joyner, Colin Kaepernick, and Megan Rapinoe—have powerfully challenged discrimination on and off the field. As eminent sports historian Harry Edwards says in the book's opening epigraph, "You can change society by changing people's perceptions and understandings of the games they play."

Artists, of course, are drawn to electric social subjects, and sports have been no exception. Many contemporary artists have responded to the inner drive of the athlete, the religious fervor of the fan, and the tension between individuals and the dominant institutions governing how games are played and who gets to play them. Often, these artists have a personal investment, having played organized youth team sports, embraced a freeform sport like skateboarding, attended college on a sports scholarship, followed professional teams, or simply performed in front of a crowd. Black athletes have been particularly active in collecting the work of Black artists, finding common cause in a mission to fight racism, promote education, and celebrate cultural achievement. Many athletes and artists share the view of their craft as a tool for shaping perspective, for making history and creating community. Some artists see a similarity to athletes in various drives: to succeed, to excel, to push themselves, to express themselves, to find grace, to change patterns, and to mentor. Athletes and artists also desire an engaged audience that is attentive to their singular performance or career-long effort.

This book, like the exhibition it accompanies, explores the multifaceted relationships between sports, culture, and artistic expression, bringing together essays by sports historians and culture writers and conversations between athletes and artists. The voices include designers, journalists, NBA and NFL players who collect art, athletes who are boxers or race car drivers, artists who take photographs or make sculptures. The essays look back to see where sports and society have been, and look forward to where we are

Art and sports celebrate the human mind and body, and they reward genius, the extraordinary individual who is simply better than everyone else. They each have their respective GOATS, and arguing about the pantheon is a kind of bracket played in both fields: Picasso versus Matisse, Jordan versus LeBron.

going and how we can do better; they also look inward, asking why we play. Artist and surfer AJ Dungo links these diverse perspectives with illustrations of iconic moments in sports history that have been collectively memorialized for their social and emotional force, their transformational impact, and their awesome beauty.

The title for this project emerged early: watching the broadcast of Serena Williams's US Open swan song, our co-curator and the co-editor of this volume, Seph Rodney, noticed NFL running back Saquon Barkley in the stands. Barkley was riveted, his own arms, shoulders, and neck moving with every swing and volley; Seph himself responded sympathetically, declaring, "Yes! Get in the game!" There is an imperative there, the kind a coach might yell from the sidelines, pushing players to center and commit themselves. There is also an invitation, extended to us all, to bond with our hero, to join the community. Within the exhibition, the imperative and invitation asks visitors to participate with body and mind alike, to consider the outsize role sports has had, especially in recent years, in the lives of artists whose work is on view, in policy, in the economy, in everyday life, and on the fields of glory. This book offers us the chance to see the true significance of this thing we love, to unfold its depth and breadth, revealing the pleasure of competition, physical intelligence, community, and sheer human will—to understand sports, like art, as one of the crowning achievements of our culture. Serious play continues to transform individuals and society alike.

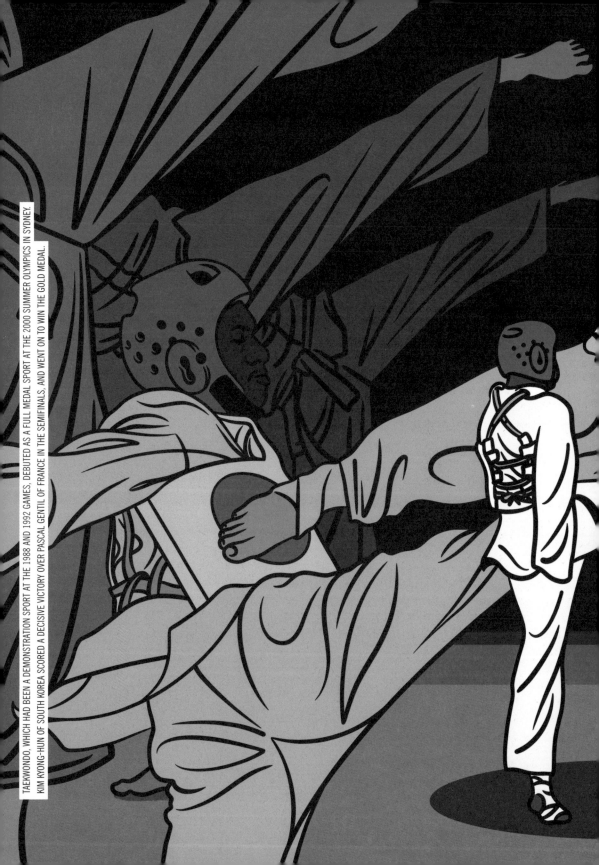

TAEKWONDO, WHICH HAD BEEN A DEMONSTRATION SPORT AT THE 1988 AND 1992 GAMES, DEBUTED AS A FULL MEDAL SPORT AT THE 2000 SUMMER OLYMPICS IN SYDNEY. KIM KYONG-HUN OF SOUTH KOREA SCORED A DECISIVE VICTORY OVER PASCAL GENTIL OF FRANCE IN THE SEMIFINALS, AND WENT ON TO WIN THE GOLD MEDAL.

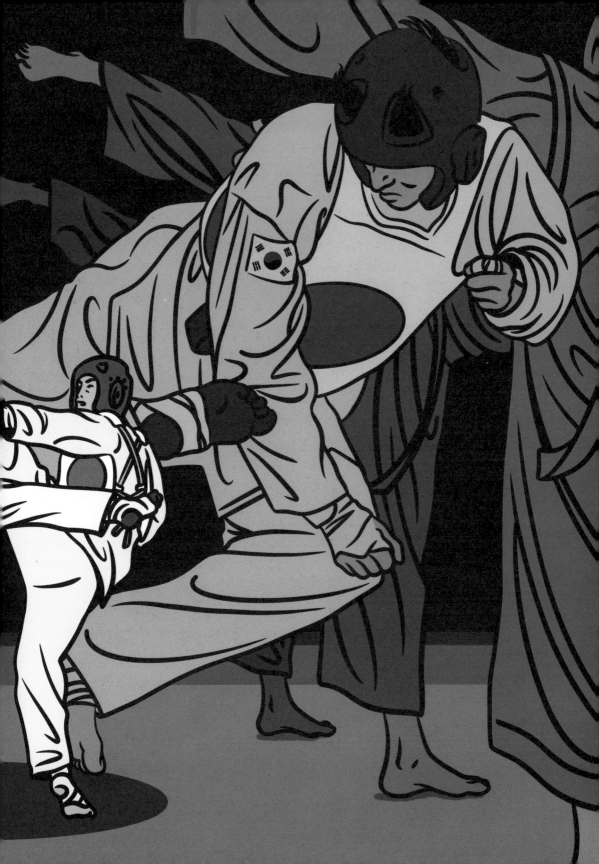

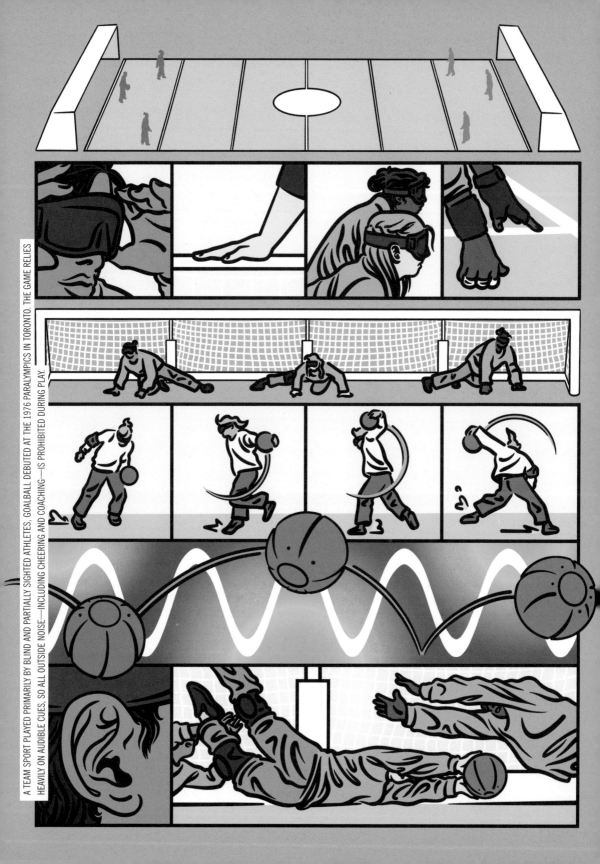

A TEAM SPORT PLAYED PRIMARILY BY BLIND AND PARTIALLY SIGHTED ATHLETES, GOALBALL DEBUTED AT THE 1976 PARALYMPICS IN TORONTO. THE GAME RELIES HEAVILY ON AUDIBLE CUES, SO ALL OUTSIDE NOISE—INCLUDING CHEERING AND COACHING—IS PROHIBITED DURING PLAY.

GOALBALL AND THE EVERYDAY PARADOX OF ADAPTIVE SPORTS

Sara Hendren

SINCE ITS INVENTION in the mid-1940s, goalball remains the only game of its kind: a physical competition explicitly choreographed for nonvisual play. The game *starts* with disability; it is not an adapted variant from a sighted sport. In goalball, two teams of three athletes face off on a court, attempting to hurl and roll a ball into the opposite side's goal while eluding the other team's full-body blockage. It proceeds like other court sports, with players trading shots and racking up points in timed halves, except all the players are blind or have low vision. A simple, central design feature of the ball—a tiny bell in the middle—transforms the sport's orientation from visual to auditory.

That crucial bell, amplified by eight small holes that project its sound, is broadcasting the ball's location, the most important signal in the competition. Other materials make the game an elegant mix of auditory skills, proprioception, and tactile information. Players

wear light-blocking eyeshades to obscure any amount of sighted play, evening out the abilities of athletes who have varying traces of vision. During games, they run their hands along the soccer-style goal's frame, made of either PVC or metal, as a spatial-orientation process to position their bodies for strategic defense. Raised tape along the edges of the court and at the midline indicates boundaries for play. With this mix of design and game rules, goalball distinctly foregrounds less well-rehearsed sensory capacities, demoting vision from its usual top status. The game is primarily a sonic one, but with eyeshade gear for all players, it becomes easily "adapted" for people who are sighted (so long as they hear and have strong knees for sliding and blocking). Blindness defines the norms of goalball. Instead of a "trickle down" model of access—expanding a sport's ordinary rules from a game that assumes a normative body—blind players "own" this game and introduce it to others.

What is materially present matters to the game, but what is absent matters too: goalball uses negative space as a crucial tool. Players need quiet to hear the trajectory of the ball, so fans show their respect by restraint. Silence, not cheers, holds the contest in its beauty and tension. Staff are placed at gymnasium doors to secure them; all peripheral noise has to be eliminated. Even more than in tennis or golf, the etiquette of quiet is sacrosanct. (During the 2012 Paralympic Games in London, Bjork's "It's Oh So Quiet" played during breaks between goalball games—a friendly gesture to remind enthusiastic fans how to behave.) Players are penalized for making noises that could disrupt the opposing team's play, but they can vocalize or rap on the floor with their knuckles to communicate with their own team about spatial positioning. These sounds, too, are such crucial parts of strategy that they depend on silence as an envelope around them. Guiding the players from the sidelines, while the clock is ticking, is also constrained. Eugenia Kriebel and Joe R. Dominguez observe in their 1988 *Goal Ball* handbook what is surely a sports lover's understatement: that "remaining silent is often the most difficult part of the coach's assignment." It's a strategic, fast-moving, ball-driven sport, requiring both familiar athletic prowess and a sensory awareness that is reshuffled and remixed from standard athletics—no visual acuity but instead a theater of quiet, the elegance of tactile clues, and the body orienting its position in roving-and-sensing moves.

Goalball is played by all ages, all over the world; it was trialed for the Paralympics in 1976 and became an official Paralympic sport at the 1980 games. Its mid-1940s origin is a telling one in adaptive sports. New forms of leisure and recreation were created for World War II veterans in many countries, men who had survived the battlefield but returned home with substantial changes to their mobility or sensory capacities. Goalball may have originated in Belgium, or Austria, or Germany—each country claims it—but many credit Hans Lorenzen and Sepp Reindl, rehabilitation workers in Austria, with its invention. International efforts at recovery for veterans, both biomedically and socially, included the development of therapeutic sports. In the United States, veterans' services were attuned to the medical healing of the wounded body as well as the civic recuperation of an honored population—and, by extension, the American nation they represented—made vulnerable by war. "Social workers, advice columnists, physical therapists, and policymakers during and after World War II turned their attention to the perceived crisis of the American veteran," writes historian David Serlin in his book *Replaceable You: Engineering the Body in Postwar America*. According to Serlin, both the Civil War and World War I had produced similar social concerns, but the post–World War II era brought veterans back into civilian life in a time of noticeable technological, pharmacological, and social advancements. The prosthetics developed for veterans in the 1940s and 1950s took a leap forward in material novelty and mechanical sophistication—scientific progress that dovetailed neatly with postwar material prosperity, the early stages of the Cold War, and cultural concerns about soldiers' "demobilization" and reentry into ordinary life. At stake were not just replacement parts for everyday functioning; there was a call for the kinds of stories and symbols and activities that would reassure veterans and their communities that a newly invented wholeness was still possible. Prosthetic devices were put to work in popular stories. In postwar Hollywood films, for instance, this meant showing heteronormative romantic relationships for vets sporting prosthetic arms. The prosthetic technology developed in this era formed what Serlin calls a "consummate marriage of industrial engineering and domestic engineering."

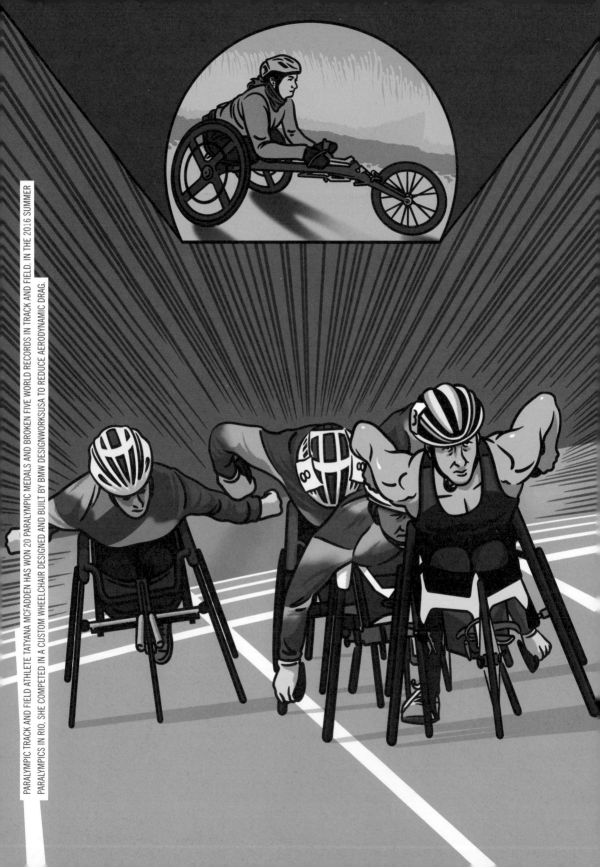

PARALYMPIC TRACK AND FIELD ATHLETE TATYANA MCFADDEN HAS WON 20 PARALYMPIC MEDALS AND BROKEN FIVE WORLD RECORDS IN TRACK AND FIELD. IN THE 2016 SUMMER PARALYMPICS IN RIO, SHE COMPETED IN A CUSTOM WHEELCHAIR DESIGNED AND BUILT BY BMW DESIGNWORKSUSA TO REDUCE AERODYNAMIC DRAG.

Sophisticated digital navigation and goalball aren't evidence of the "superhuman" capacities of blind people. No strange hyperbole is needed.

What an everyday paradox too—that the body might be recuperated by play, by the artificial bounds of a game, a form of leisure that can't be neatly instrumentalized.

How interesting, then, that adaptive sports grew into formalized structures in this same period. The pattern is a common one: innovation for disability catalyzed in wartime conflict and, later, codified and domesticated into the mainstream. In 1948, a dozen years before the formalization of the official Paralympic Games, more than fifteen thousand spectators showed up at Madison Square Garden to cheer on two makeshift teams of wheelchair basketball players, all of them veterans who had recovered in two hospitals, one in New York and one in Massachusetts. Paraplegia had been made newly survivable by penicillin, sulfa drugs, blood transfusions, and technological advances. But sports made life with adaptive gear into something newly public—and playful.

What an everyday paradox too—that the body might be recuperated by play, by the artificial bounds of a game, a form of leisure that can't be neatly instrumentalized. The cultural theorist Johan Huizinga posited the universality of this impulse when he coined his famous name for this mystery, *Homo ludens,* or the "human who plays," as counterpart to the "human who knows or makes." Play, he claimed, is part of the bedrock of human instinct, both an animal behavior and something else besides. "Nature," he writes in *Homo Ludens: A Study of the Play-Element in Culture,* "so our reasoning mind tells us, could just as easily have given her children all those useful functions of discharging superabundant energy, of relaxing after exertion, of training for the demands of life, of compensating for unfulfilled longings, etc., in the form of purely mechanical exercises and reactions. But no, she gave us play, with its tension, its mirth, and its fun." For the wounded soldiers of world wars, the recompense for great sacrifice would be paid, in part, in *fun.*

And the vitality of play continues. The twenty-first century has become a golden era for adaptive sports made commonplace—clever work-arounds for skiing and sailing and rock climbing. The material culture encompasses a whole array of gear, low tech and high tech. There are short looped tethers that connect blind and sighted runners for guided races, and the small metal release on an archer's bow that connects a prosthetic arm for pulling. There are extra wheels at a wide-angle pitch for wheelchair basketball, and the recombined spinner and trigger mechanisms on one-handed fishing rods. Designs might expand a traditional sport's requirements just a little, like handgrips on a bowling ball. Or they might be distinctive substitutes for standard sports, like the wooden "club

throw" that swaps in for the wire-and-metal hammer throw field event. Wheelchair rugby—known colloquially as "murderball"—was profiled in an Oscar-nominated documentary film of the same name in 2005. And the decades-long tradition of the Special Olympics has extended some of its efforts to an ingenious and inclusive form—Unified Sports, a set of mixed-ability basketball and track leagues for teenagers with and without developmental disabilities, integrated into public school districts all over the United States. Play, it seems, makes use of theater for that elusive social good: camaraderie across human difference in the lightness and levity of a game, without the stilted and elaborate structures of forced togetherness, without patronizing sentimentality.

Goalball, too, is still a strong part of the culture at K–12 schools like Perkins School for the Blind outside Boston, the famous institution where Helen Keller was educated. Perkins regularly hosts sighted guests on its campus to play goalball against its students; in recent years, professional hockey players from the Boston Bruins have visited to test their skills. The games get reported in the local news because the young students invariably hold their own against these elite adult athletes, dramatically narrowing the contest and shaping a narrative that registers surprise: that the game inverts the ability paradigm for everyone in the room, and that students sequestered in specialized education programs also, in the right circumstances, excel. But why should it be surprising that the adaptive body operates on a principle that is both commonsensical and infinitely complex in its implications? Or that each body's faculties will shift in response to changes, making any one person's abilities a profile of peaks and valleys, strengths and weaknesses, not simply a single global metric of "skilled" or "unskilled"? Witness a blind person listening to their email on a smartphone or navigating a computer screen by voice commands. Their speed and deftness are such that the average sighted bystander is left unable to comprehend. But sophisticated digital navigation and goalball aren't evidence of the "superhuman" capacities of blind people. No strange hyperbole is needed, no matter how well-intentioned. The truth is at once more ordinary and more extraordinary. The principle of adaptation is universally operative, a habitable universe of sensory and cognitive comprehension that is patched together, evolving and responding over a life span in any embodied state. When vision recedes, auditory and olfactory and proprioceptive abilities come forward—the truest sign of the body's deep plasticity, its endless learning.

Disabled sports
are the only kind there are.

—Steven Connor

In his 1978 book *The Grasshopper: Games, Life and Utopia*, philosopher Bernard Suits distills "playing a game" to "the voluntary attempt to overcome unnecessary obstacles," which is an elegant formulation for the mystery of sports: choosing limits that create the conditions for striving. In what other arena of life are obstacles so eagerly sought—and in the name of play? For philosopher Steven Connor, the generative limitations in *all* sports should redefine sports as inherently disabling—universally disabling for productive ends. "The restrictions," he writes in *A Philosophy of Sport*, "offered by . . . projectors and projectiles," along with the "times, places, and rules of behavior" of all games are "not mere background conditions for the exercise of freedom. They are, like the body itself, both a restricting necessity and an enabling form of limit that is necessary for me to be able to assert my freedom." Connor pushes this challenging concept, even venturing to say that this limits-for-freedoms structure is so integral to sports that we might dissolve all distinctions between, say, Olympics and Paralympics. It's a provocative (and debatable) idea. The material design and culture of goalball—the bell as signal, eyeshades and tactile boundaries, rules for suspense-filled silence—carry its postwar history and its invitation to see every physical contest differently. "Disabled sports," he claims, "*are the only kind there are.*"

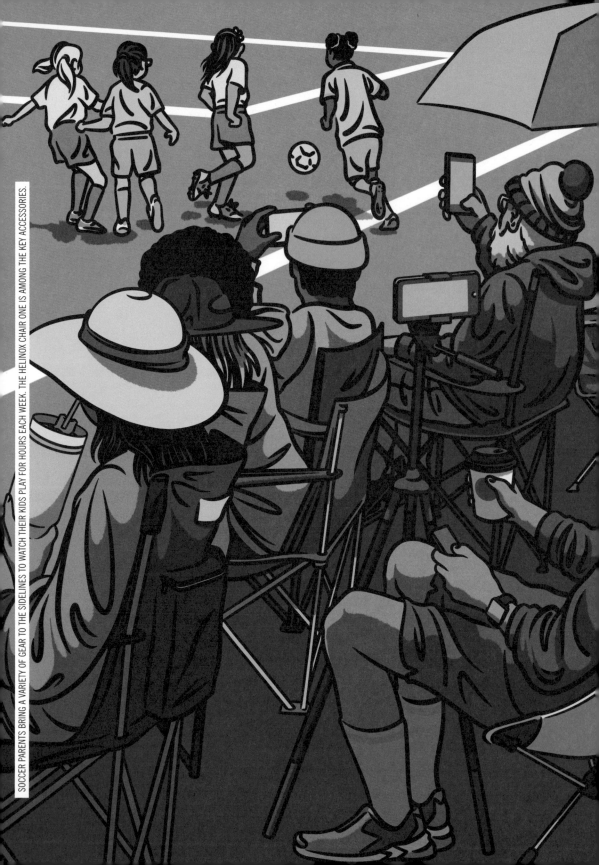

SOCCER PARENTS BRING A VARIETY OF GEAR TO THE SIDELINES TO WATCH THEIR KIDS PLAY FOR HOURS EACH WEEK. THE HELINOX CHAIR ONE IS AMONG THE KEY ACCESSORIES.

MY HELINOX CHAIR ONE

Jay Caspian Kang

THE HELINOX CHAIR ONE is 25½ inches high, 19½ inches across, and an extraordinarily lightweight one pound, fifteen ounces. The assembly, which takes about a minute but requires a reasonable amount of arm strength, involves some tent poles and a mildly waterproof quilt of canvas and mesh that's just sturdy enough for a hundred-and-ninety-pound middle-aged father of two.

If you, like me, spend what feels like both a luxurious but also unseemly amount of time at your child's soccer practices and games, I humbly suggest the compactness and portability of the Helinox Chair One. It allows you to sit comfortably on the sidelines and, because it's slung close to the ground, you can quietly sink into reverie while you watch your six-year-old kick the ball around. Or if you feel a twinge of anxiety over what's happening on the field (again, between six-year-olds), or need to mask a look of clear disappointment when your child stands idly by as the real athlete, the one with the screaming parents, runs confidently down the field, the Helinox Chair One provides enough give for you to slink as far down as you'd like.

The main drawbacks are the price ($102) and the fact that the legs, which are just tent poles, tend to sink into soft, wet ground. So, if you live in a rainy climate or if your child's fields are always soggy for whatever reason, you might want to save yourself the money and just get a normal camping chair with broader feet.

The Helinox Chair One also collapses down and can be stowed in a three-ounce carrying case that's about the size of a sourdough loaf. This fits neatly inside the Cotopaxi Allpa 60-Liter Gear Hauler Tote, which has a variety of pockets for extra socks, shin guards, and snacks. The main compartment is wide enough to fit two soccer balls, water bottles, cleats, orange plastic cones, and even a folded-up Pugg miniature goal. This portability is key because it allows you to walk from your car to the field without lugging around one of the larger, longer-legged camping chairs. What do you do with one of these monstrous and heavy chairs? Do you stick it under your arm? Do you sling it over your shoulder? Or do you do that awkward walk known to all soccer parents, where you grab your child's wrist with one hand while awkwardly holding an unbalanced and too-long folding camping chair in the other? Inevitably, either the wrist or the chair wriggles out of your grasp or, even worse, one of them slips a bit, throwing off the weight balance, which means you either stop and rearrange everything all over again or you stumble toward the field with the heavy, giant, bad camping chair's legs knocking against your knee or back or the ground. Who, really, has the patience for any of that?

LAST YEAR, I HAD TWO HELINOX CHAIR ONES. One was black and neon pink; the other was an orange-and-blue tie-dye. When chairless parents came to practice, I would sometimes offer them the second chair, which I hoped lent me an air of magnanimity that would cut against what I had already identified as my raging case of soccer dad syndrome. When my daughter was five, my wife and I put her in a local recreational soccer league with kids who were born in the same year. I promise we had no expectations for any of this, nor did we know if she was good or not. Most parents, I imagine, periodically gauge their child's athletic talents through a series of little questions: Can she do the monkey bars like the other kids? Can she run in a straight line? Can she throw with even a modicum of grace and confidence? Our daughter, at the time, had passed all those assessments, but my wife and I aren't particularly gifted athletes and we had no real hopes for our child.

Then she started playing and it was clear that some talent had either skipped a generation or had been randomly borne from the chaotic clashing of unathletic genes. I will not embarrass myself or my child and give any details or cite any stats, but by the end of that season, I had researched all the competitive girls' soccer clubs within a fifty-mile radius of our home, signed my daughter up to play with boys' leagues, and watched hours of YouTube tutorials on backyard soccer drills.

We only have so many choices as parents in America, and while we might know that our children will not be getting those college scholarships or playing professionally, we might just feel the need to show them that the ladder indeed exists and that, whether they like it or not, they will have to get used to its cold touch.

This syndrome should be diagnosed, so let's first discard the more well-known theories of its origins. Although I do watch an unusual amount of sports—including football, basketball, mixed martial arts, boxing, and baseball—soccer has never really appealed much to me outside of the pageantry and nationalistic weirdness of the World Cup. While I am certainly open to the possibility that I might be deluding myself, I don't think that some deferred dream from my own childhood was behind all this. Nor was there some clear vision of a college scholarship that captivated my attention while I watched my daughter run through five-year-old defenders, many of whom were distracted by soggy dandelions that litter every field in the Bay Area. College sports are fun to watch, but I mostly find myself feeling bad for the athletes, who are always at practice or training and spend every weekend on a bus to Irvine or San Luis Obispo or wherever.

The actual answer—at least the one I've settled on—is much simpler. Youth soccer where we live in the Bay Area is set up as a hierarchy with a seemingly endless procession of winnowing ceremonies. Your child starts in a recreational league, then goes up to a club academy where they're evaluated on whether they can hack it in a competitive league, then they start "comp," which is itself divided into tiers, which then eventually runs up to the first real test, which is whether your child, who will probably be only nine or ten years old, will qualify for one of the premier teams that funnel into Girls Academy or Elite Clubs National League. Who, when presented with so many hierarchies, small selections, and an endless supply of affirmations or negations, has the rationale and the guts to simply walk away? We climb these ladders because they exist, not because they promise to take us anywhere. We only have so many choices as parents in America, and while we might know that our children will not be getting those college scholarships or playing professionally, we might just feel the need to show them that the ladder indeed exists and that, whether they like it or not, they will have to get used to its cold touch.

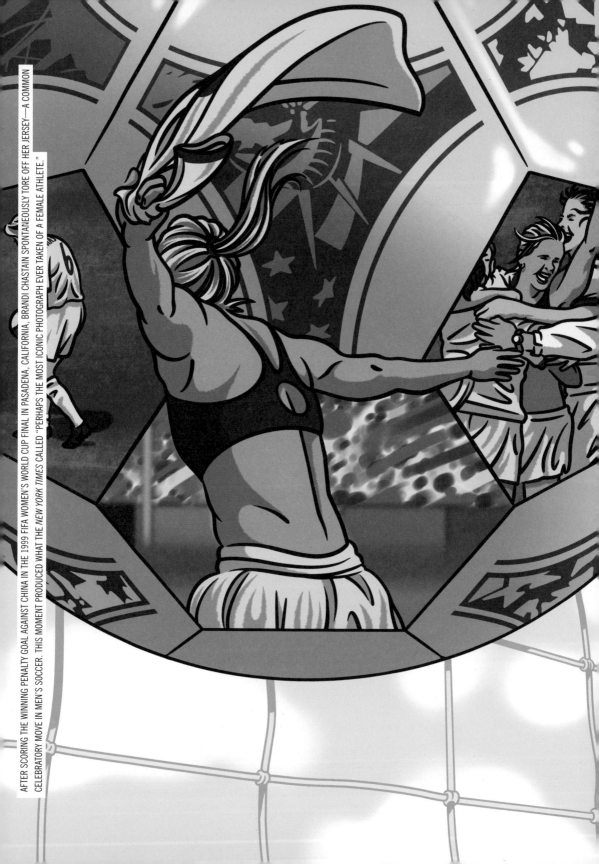

AFTER SCORING THE WINNING PENALTY GOAL AGAINST CHINA IN THE 1999 FIFA WOMEN'S WORLD CUP FINAL IN PASADENA, CALIFORNIA, BRANDI CHASTAIN SPONTANEOUSLY TORE OFF HER JERSEY—A COMMON CELEBRATORY MOVE IN MEN'S SOCCER. THIS MOMENT PRODUCED WHAT THE *NEW YORK TIMES* CALLED "PERHAPS THE MOST ICONIC PHOTOGRAPH EVER TAKEN OF A FEMALE ATHLETE."

Part of our job as parents is to teach our children the contours and the pitch so they can decide for themselves … whether the whole thing is worth the effort.

I LOST THE SECOND HELINOX CHAIR ONE. For a while, I thought it had been stolen out of my van, which made no sense, really, because I cannot imagine a thief would overlook all the other junk that was sitting in my van and fixate on the lightweight, albeit wildly expensive camping chair. But I did pick up a small community of other dads with their own camping chairs. Three times a week, we set up at the edge of a field that sits between the 80 freeway and the eastern edge of the bay. The goose shit is intolerable—you can't take five steps without coming across another fresh brown-and-white log—and the wind whipping off the water can be quite chilly and miserable.

There is also a ritual to soccer parenting that I've come to enjoy. Before we leave for practice, I stock the Cotopaxi Allpa 60-Liter Gear Hauler with trail mix and goldfish crackers, wipe down the legs of the Helinox Chair One, stash an L.L.Bean waterproof picnic blanket on the days when my toddler son joins us, and fill up a water bottle with ice. These are all little forms of control, of course, but they are relatively banal. I did not expect parenting could be so pleasant, or so social. The other dads and I talk about nothing of any importance—real estate, basketball, parent-teacher conferences—and try our best to not talk too much about the children who are running around in front of us or our assessments of their chances of climbing up into the next layer of the infinite soccer hierarchy, which, of course, is the only reason why we are all out there.

One day, our children will separate from one another. They will fail a tryout or they will get promoted to another club or perhaps one of us will decide that there are better soccer opportunities somewhere else. That doesn't make any of this less pleasant. Nobody stares at their phone; nobody complains; and we all appreciate that we are not the type to express our deep ambitions for our children in any impolite or unseemly way. There's something edifying and certainly instructive about suppressing the mania while also acknowledging that our country is filled with similar ladders, and that part of our job as parents is to teach our children the contours and the pitch so they can decide for themselves—one day, but not now—whether the whole thing is worth the effort.

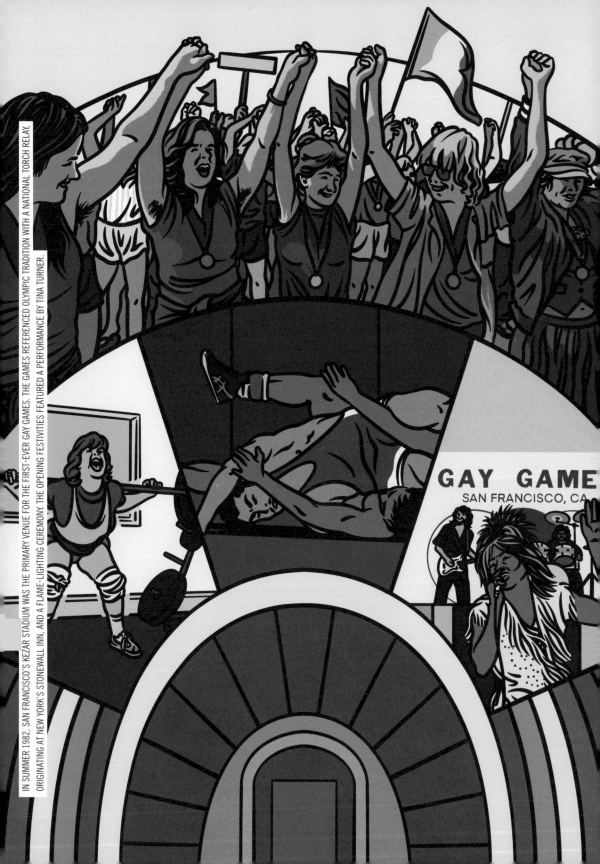

IN SUMMER 1982, SAN FRANCISCO'S KEZAR STADIUM WAS THE PRIMARY VENUE FOR THE FIRST-EVER GAY GAMES. THE GAMES REFERENCED OLYMPIC TRADITION WITH A NATIONAL TORCH RELAY, ORIGINATING AT NEW YORK'S STONEWALL INN, AND A FLAME-LIGHTING CEREMONY. THE OPENING FESTIVITIES FEATURED A PERFORMANCE BY TINA TURNER.

GAY GAME
SAN FRANCISCO, CA

WHAT IS THE VALUE OF A STADIUM?

Frank Andre Guridy

STADIUMS HAVE BEEN an enduring part of the Bay Area landscape, as they have in other parts of the country, for more than a century. In the 1920s, fans began gathering at Kezar Stadium on the edge of Golden Gate Park to watch high school and college sporting events. As professional sports franchises began to dominate the attention of fans in the 1960s, spectators watched football or baseball along the city's frigid and gusty waterfront at the then new Candlestick Park until it was demolished in 2015. A similar dynamic took place across the bay in Oakland, where fans began to make their way to the Oakland Coliseum complex in the 1960s to watch Warriors, Raiders, and A's games. In recent decades, Oracle Park and the Chase Center were built in downtown San Francisco to host sports, concerts, and community events. Bay Area residents have enjoyed countless memorable performances in these facilities and others, and they will continue to do so for years to come.

Today, in an era when social interaction is increasingly shaped by digital technologies and political polarization, the stadium remains one of the few areas of in-person socializing between Americans of different backgrounds.

And yet the stadium has been more than a sports and entertainment venue. It is an institution that brings people together for all sorts of purposes on a recurring basis. Its primary benefit is social. Although they are mostly known for housing virtuosic athletic performances, their size and visibility in the city landscape make them ideal platforms to articulate and amplify a community's aspirations. The Black Freedom, anti-war, feminist, and gay liberation movements of the 1960s, '70s, and '80s staged their visions of a more inclusive and just society. This is especially evident in Bay Area stadium history, where local arenas became prominent locations of social integration across the lines of race, gender, and sexuality. Today, in an era when social interaction is increasingly shaped by digital technologies and political polarization, the stadium remains one of the few areas of in-person socializing between Americans of different backgrounds.

Yet these social benefits are being undone by the very industry that helps make them possible. With increasing frequency during the past few decades, the primary tenant, the local sports franchise, inevitably decides that a new stadium is necessary to generate more revenue to enable it to field competitive teams, and these new facilities tend to demand more public dollars for construction. The phenomenon of the publicly financed stadium, which began in earnest when the United States became an increasingly sports-crazed nation in the years after World War II, has continued virtually unabated through the present day. This recurring pattern is a product of the de jure and de facto monopoly status enjoyed by major American sports leagues, which empowers them to compel public officials to hand over millions of taxpayer dollars. When sports franchises are unable to coerce local officials to build the new stadium, they often move to another city that is willing to do so. Local examples of this trend abound. Both the Raiders and the Warriors left the East Bay for fancier facilities elsewhere, with the Warriors moving across the bay to become part of San Francisco's downtown sports scene. During the summer of 2023, the A's baseball franchise followed suit when it announced its planned move from Oakland to Las Vegas.

The struggle over the meaning and value of the stadium shows how it is, and always has been, a political institution. Indeed, stadiums have been much more than places to witness sporting spectacles; they have a political and social function that is deeper than many

DODGER STADIUM WAS BUILT ON A LOT AT CHAVEZ RAVINE THAT HAD BEEN ACQUIRED BY THE CITY OF LOS ANGELES THROUGH EMINENT DOMAIN, DISPLACING A COMMUNITY OF PRIMARILY MEXICAN AMERICAN RESIDENTS. OPENED IN 1962, IT HAS BECOME ONE OF THE OLDEST AND MOST ICONIC BALLPARKS IN THE US AS WELL AS A POPULAR CONCERT VENUE.

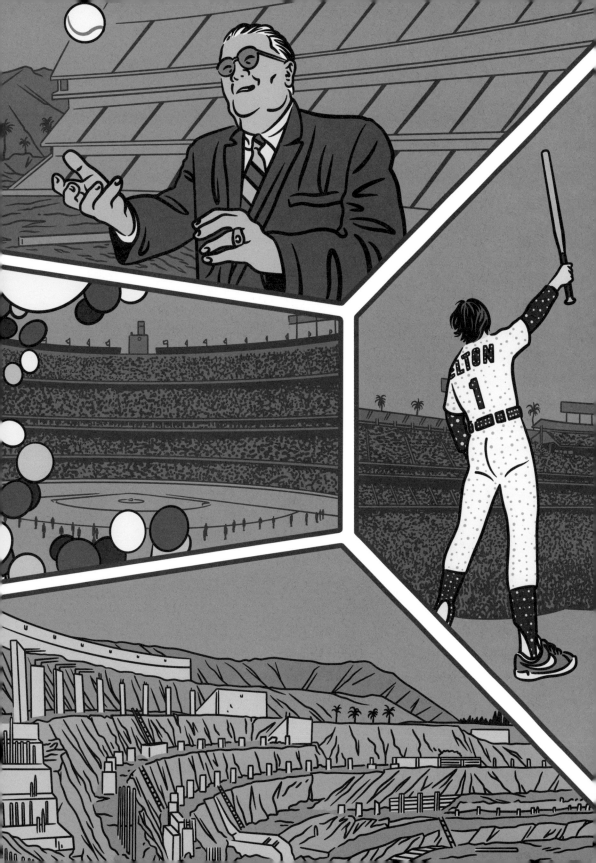

realize. Over the years, elites have used them to further their agendas by turning games into celebrations of war, white supremacy, and patriarchy. At the same time, stadiums have been important sites of protest: activists have turned them into arenas to challenge racism, fascism, sexism, and homophobia. The movements of the 1960s, '70s, and '80s—including Civil Rights, anti-war, feminist, and gay liberation—brought together a wider spectrum of spectators as they organized rallies and protests in stadiums in the Bay Area and all over the country. Athlete-activists such as Colin Kaepernick and Megan Rapinoe, among others, belong to a longer history of stadium protest. Stadiums are arenas of political struggle as much as they have been palaces of pleasure.

How did stadiums become prominent institutions in American society? Though their origins date back to ancient Greece and Rome and Mesoamerica, in the United States they first emerged in the years after the Civil War, as wooden ballparks and circus tents were built for the popular amusements of the nineteenth century. In the early 1900s, the advent of concrete and steel construction made stadiums more permanent, producing the classic ballparks of Chicago's Wrigley Field, Boston's Fenway Park, and many other beloved baseball cathedrals. Yet the ballpark was but one of a variety of stadiums where Americans could find entertainment. The rising popularity of college football in the 1920s led universities to build massive structures such as Stanford Stadium for fans to watch the exploits of young men on the gridiron. Public works projects launched by the New Deal in the 1930s led to the construction of facilities for scholastic competitions all across the country. But it wasn't until the decades after World War II that the stadium became a ubiquitous institution. The exploding popularity of professional basketball, football, and hockey spawned the construction of a variety of indoor and outdoor facilities. The 1950s marked a pivotal moment in Bay Area and California sports history when the Giants and Dodgers arrived from New York. Within a decade the arrival of other franchises, such as the Warriors and Lakers, and the creation of the Angels, Kings, and Padres, among other teams, led to the construction of more stadiums and arenas. California soon became home to key markets in the rapidly growing national professional sports industry in the second half of the century.

More stadiums meant more fun times for fans and more revenue for team owners but also more debt for the municipalities that financed them. Sports franchises regularly argue that stadiums are worthwhile public investments that generate economic development and job creation, and they are touted as engines of revitalization. However, decades of research by economists have challenged this unquestioned orthodoxy, citing the substantial body of evidence that stadiums have minimal impact on the economic development of the cities that build them. In fact, they are money pits that seldom translate into financial surpluses. Stadium construction costs are skyrocketing beyond a billion dollars—the bigger and more technologically advanced they are, the more costly they are to build and maintain—while cities struggle to fund essential services for residents. As the twenty-first century unfolds, it seems apparent that the price for enjoying the community benefits provided by stadiums is simply too high.

What then is the value of the stadium? Their redeeming quality is best understood as a social one, and an examination of the experience of African Americans at stadiums makes this clear. Throughout the century, the Black Freedom struggle had long advocated for equal opportunities for Black athletes and equal access to the arenas for Black fans. Although restrictive covenants, job discrimination, and police violence created an oppressive environment, they did not prevent African Americans from entering the playing fields and contributing to the country's rich sporting cultures. The experience of Giants baseball legend Willie Mays soon after his arrival in San Francisco illustrates this dynamic. Outside the ballpark, he encountered racial discrimination when he first attempted to buy a home in San Francisco in the late 1950s; inside the park, the ball field was his domain and he became a beloved figure.

Mays's experience as a Black player on the field is paralleled by the experience of Black fans in the stands at stadiums throughout the region. Over the almost sixty years that the Oakland Coliseum has existed, it has been one of the few spaces where East Bay residents have congregated across racial and class boundaries. Like many stadiums built in the mid-twentieth century, it was envisioned as an urban renewal project, which often resulted in the allocation of public resources away from poor and working-class communities. Yet a genuine form of racial integration has prevailed at the Coliseum. Black, Latinx, white, and Asian American fans, among others, have walked through the stadium and the arena's turnstiles and expressed their love and loyalty for the city's teams for decades. The Coliseum became a place all Oakland residents could enjoy.

The stadium continues to be ... an arena that reflects and enacts a community's desires and discontents.

San Francisco's Kezar Stadium also exemplifies the social impact of a stadium on a community. First built as a multipurpose athletic facility in 1925, it was home to high school teams while also serving the 49ers during their first twenty-five seasons. After the 49ers moved to Candlestick Park in 1971, Kezar continued to be a community institution. In addition to its role as a venue for high school sports, it became a public square of sorts, where massive rallies against the Vietnam War took place in 1967 and 1972. Kezar was also the site of a number of memorable rock concerts in the 1970s. Bill Graham, the legendary San Francisco–based rock promoter, helped shepherd in this sea change in American entertainment, and one of his most unforgettable endeavors was the SNACK concert in 1975. SNACK—Students Need Athletics, Culture and Kicks—was a benefit concert to raise money for kids who were going to be negatively affected by proposed budget cuts eliminating arts and sports programs in the city's public schools. More than fifty-five thousand spectators packed the facility to enjoy a stunning lineup of performers that included the Doobie Brothers, Carlos Santana, Tower of Power, Jefferson Starship, the Grateful Dead, Joan Baez, and Bob Dylan.

Kezar hosted countless events over the years, but it had never staged anything quite like the Gay Games. On August 28, 1982, a modest but very vocal crowd of ten thousand people made its way into the sixty-thousand-seat stadium to witness the opening ceremonies of the first Gay Games. The Gay Games movement was an extraordinary grassroots effort, led by former Olympian Tom Waddell, to create an international sports competition that was an antidote to the homophobic and hypercompetitive Olympic Games.

The Gay Games was a major success. The opening ceremonies brought tears to many eyes as over thirteen hundred gay and lesbian athletes from across the United States and other parts of the world triumphantly paraded around the field. The spectacle of athletes carrying flags and signs representing their country and their sexual orientation openly and unapologetically was a galvanizing moment for those who witnessed it. The scene repeated itself four years later, when organizers held Gay Games II in 1986 in the face of the AIDS crisis. The Gay Games was a major victory for LGBTQ communities, and it showed how grassroots movements could make use of stadiums to craft novel visions of sports, social justice, and community formation.

Today, Kezar lives on as a scaled-down facility that caters to neighborhood residents but, too often, stadiums built for the sports industry turn into white elephants. Nonetheless, the Bay Area provides models for what the twenty-first-century stadium might be. Unlike most of the stadiums and arenas built for professional teams, Oracle Park and the Chase Center are both largely privately financed. The apparent success of these venues suggests that sports franchises need not be entitled to public subsidies. However, it is also clear that both facilities, like the city itself, tend to cater to the twenty-first-century urban gentry, and the cross-racial and cross-class crowds of Kezar, Candlestick, and the Oakland Coliseum are hard to locate. Oracle and Chase are not alone in this regard: the gentrification of the stadium is a national phenomenon.

Private ownership is clearly one approach to relieve the public of the enormous financial burden of construction, but the likelihood of continued public investment suggests that citizens need to insist upon fairer arrangements between cities and sports franchises. The entitled attitude of most sports teams when they demand new facilities lead many to forget that the teams are tenants, not owners.

Bay Area history illustrates that alternative visions of sports and community are indeed possible. The recent mobilization of Oakland A's fans to stop the impending departure of the franchise for Las Vegas is a testament to the team's social impact on the city. Fans have done more than simply express their outrage. They have also raised questions about who owns sports teams and the venues where their games are played. At the same time, the Oakland Roots and Soul soccer franchises are experimenting with models of community team ownership. As sports franchises continue to demand subsidies for new stadiums, these Oakland-based movements are providing glimpses of a possible new relationship between sports and the venues where they are played. Today, the stadium continues to be, as it always has been, more than a place to see the games that athletes play. It is an arena that reflects and enacts a community's desires and discontents.

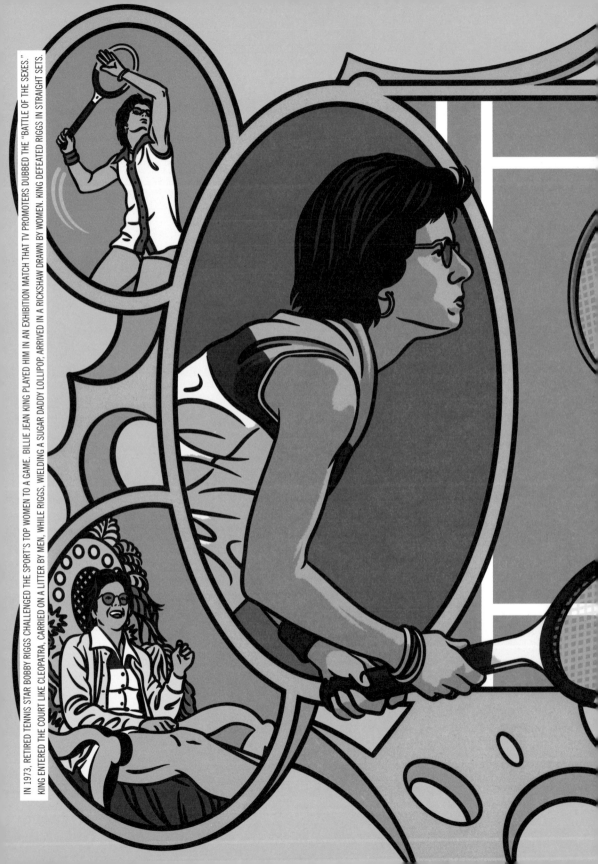

IN 1973, RETIRED TENNIS STAR BOBBY RIGGS CHALLENGED THE SPORT'S TOP WOMEN TO A GAME. BILLIE JEAN KING PLAYED HIM IN AN EXHIBITION MATCH THAT TV PROMOTERS DUBBED THE "BATTLE OF THE SEXES." KING ENTERED THE COURT LIKE CLEOPATRA, CARRIED ON A LITTER BY MEN, WHILE RIGGS, WIELDING A SUGAR DADDY LOLLIPOP, ARRIVED IN A RICKSHAW DRAWN BY WOMEN. KING DEFEATED RIGGS IN STRAIGHT SETS.

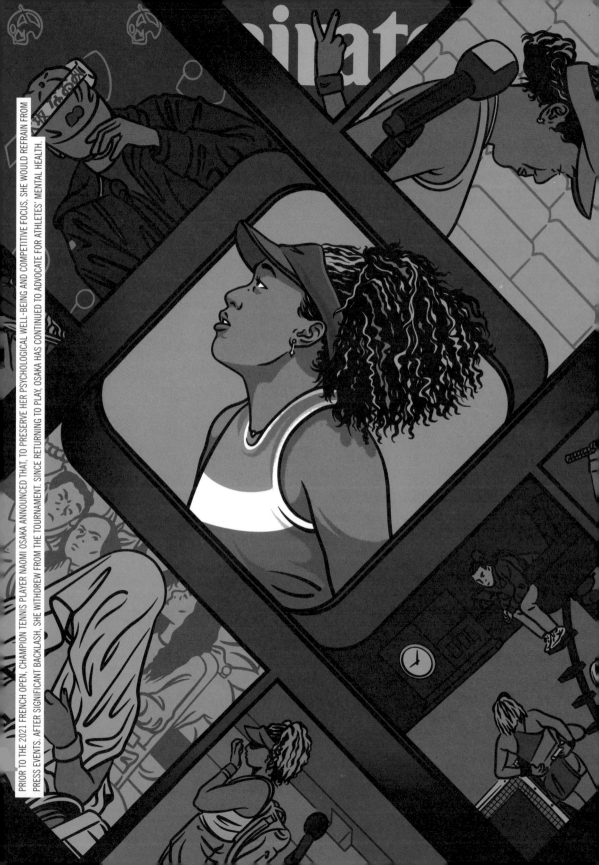

PRIOR TO THE 2021 FRENCH OPEN, CHAMPION TENNIS PLAYER NAOMI OSAKA ANNOUNCED THAT, TO PRESERVE HER PSYCHOLOGICAL WELL-BEING AND COMPETITIVE FOCUS, SHE WOULD REFRAIN FROM PRESS EVENTS. AFTER SIGNIFICANT BACKLASH, SHE WITHDREW FROM THE TOURNAMENT. SINCE RETURNING TO PLAY, OSAKA HAS CONTINUED TO ADVOCATE FOR ATHLETES' MENTAL HEALTH.

SELF-PRESERVATION IS AN ACT OF ATHLETIC ACTIVISM

Theresa Runstedtler

> Caring for myself is not self-indulgence, it is self-preservation,
> and that is an act of political warfare.
> —Audre Lorde, *A Burst of Light and Other Essays*, 1988

IN THE WEE HOURS of the morning on February 17, 2018, in Los Angeles, in the quiet moments away from the hustle and bustle of the NBA's All-Star weekend, DeMar DeRozan, then of the Toronto Raptors, tweeted, "This depression get the best of me . . ." Although excited about reuniting with his extended family, the normally private and quiet Compton native had a lot on his mind. He was set to play in the NBA's premier showcase at the same time his father, Frank, was fighting kidney disease and other serious health issues.

Those who knew hip hop realized that DeRozan had quoted Kevin Gates's "Tomorrow," a haunting track about the trap artist's struggles with stress, grief, and depression. For those who didn't immediately recognize the lyrical reference, it was nonetheless clear that the twenty-eight-year-old ballplayer was hurting—even on the eve of his fourth All-Star appearance. As he later told Doug

Smith of the *Toronto Star*, "It's one of them things that no matter how indestructible we look like we are, we're all human at the end of the day. We all got feelings. . . . Sometimes . . . it gets the best of you, where times everything in the whole world's on top of you."

Despite DeRozan's courageous revelations about his struggles with depression, the adoption of "load management" by some NBA teams—the practice of resting players to protect them from fatigue, burnout, and overuse injuries—has been roundly debated in mainstream sports media outlets (such as *The Athletic*). Given that recent data from Statista indicates the league's workforce to be over 70 percent African American (the Blackest of all the North American professional sports leagues), it's hard to ignore the racism underlying some fans' and sports commentators' criticisms of load management as symptomatic of a broader "culture of weakness" among today's athletes: one that coddles "entitled" (Black) players at the expense of the enjoyment of (white) spectators. As NBA salaries have increased over the years, Alex Kirshner observed in *Slate* in February 2023, "Some NBA fans have forgotten about their favorite players' humanity . . . and sometimes it has manifested in verbal abuse of a Black player base that too many fans believe should perform at their whim."

DeRozan is just one of many African American athletes using their visibility to not only normalize discussions of mental health but also to highlight the unrealistic expectations of the commercialized sports industry—an industry whose profitability requires athletes to execute superhuman feats *and* submit to increasingly invasive public scrutiny. The advent of social media has proven a double-edged sword for Black athletes. Although they no longer have to rely on the white-controlled sports media to tell their stories, they are now more subject to the unfiltered racism of fans and commentators alike.

The recent revelations
of DeRozan, Osaka, Biles,
and others ... build on
an abiding Black critique
of the system.

Even in the face of intense misogynoir, Black women athletes have been among the most forthright about the mental health struggles resulting from these rising pressures. Naomi Osaka endured public vitriol when she pulled out of the French Open in May 2021, after officials fined her $15,000 for skipping her media obligations to protect her mental well-being. Explaining her decision to step away from the press conference (and ultimately the tournament) on Instagram, she went public for the first time about her ongoing challenges with depression and anxiety.

Osaka's major tournament wins (two Australian Opens and two US Opens) and her ranking as the second seed in the French Open had only made her a bigger target for conservative media and fans. White conservative men were especially quick to criticize her. In a column for the *Daily Mail*, Piers Morgan accused the twenty-three-year-old Black Japanese tennis star of "weaponizing mental health," while the *Telegraph*'s chief sportswriter, Oliver Brown, called her a "diva." Conservative commentators attacked her again after hecklers made her cry at Indian Wells in March 2022 and she skipped the post-match news conference, prompting this heated Twitter response from one of Osaka's Black male fans: "To the Fox News, shut up and dribble, all lives matter . . . let's not focus on mental health crowd. Please and kindly shut the fuck up. Naomi Osaka is human and she is more than just an athlete and is right to speak up about mental health."

A few months later, African American gymnast Simone Biles decided to withdraw from the Tokyo Summer Olympics, citing mental health reasons. During the qualifying rounds, the veteran competitor had experienced bouts of what gymnasts call the "twisties," a terrifying loss of spatial awareness that makes it difficult to safely complete high-level skills. Although supported by many loyal fans, Biles faced an intense backlash from conservative Twitter. Some called her a "quitter," while others questioned her patriotism and her commitment to her team. Like Osaka, Biles's unprecedented record—she then had nineteen world championship gold medals, four Olympic golds, and four gymnastic elements named after her—did little to shield her from racist and sexist contempt.

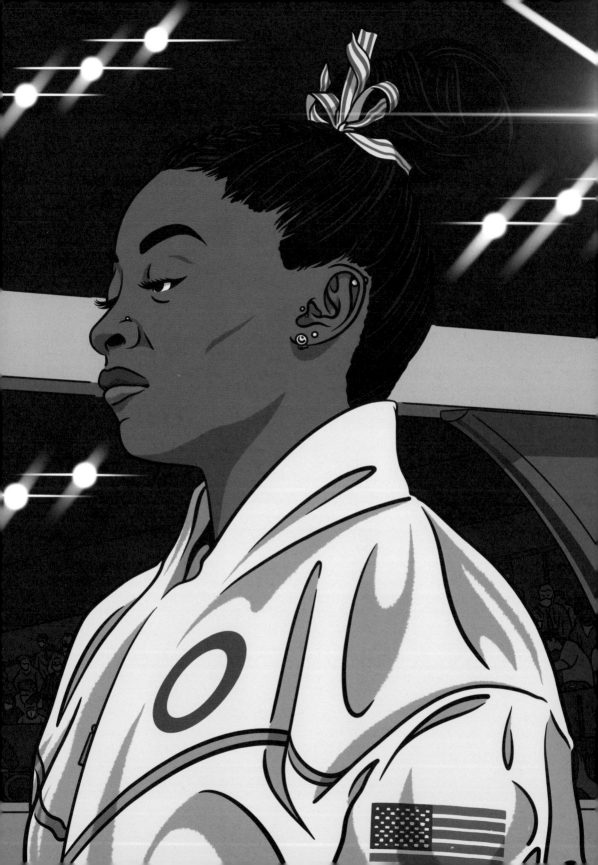

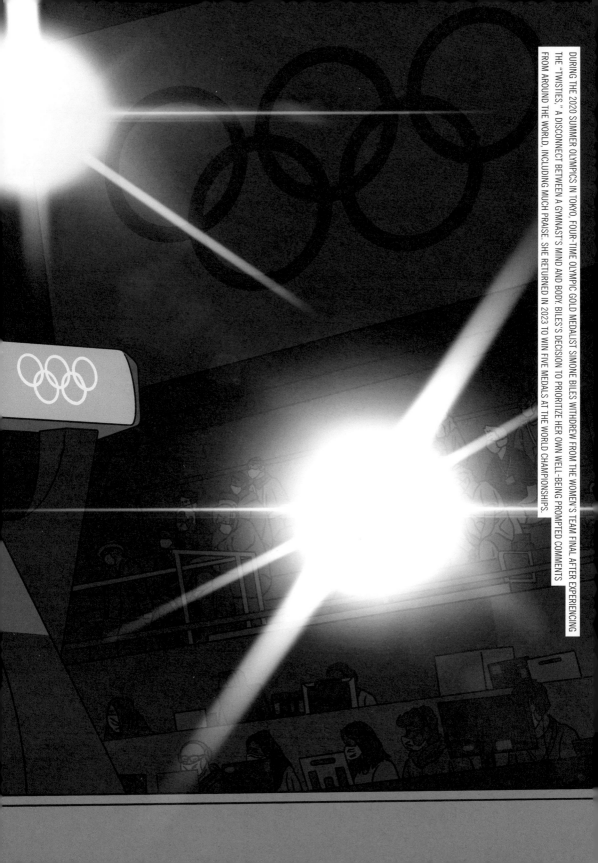

DURING THE 2020 SUMMER OLYMPICS IN TOKYO, FOUR-TIME OLYMPIC GOLD MEDALIST SIMONE BILES WITHDREW FROM THE WOMEN'S TEAM FINAL AFTER EXPERIENCING THE "TWISTIES," A DISCONNECT BETWEEN A GYMNAST'S MIND AND BODY. BILES'S DECISION TO PRIORITIZE HER OWN WELL-BEING PROMPTED COMMENTS FROM AROUND THE WORLD, INCLUDING MUCH PRAISE. SHE RETURNED IN 2023 TO WIN FIVE MEDALS AT THE WORLD CHAMPIONSHIPS.

Black athletes are expected to shut up and play.

Although the recent revelations of DeRozan, Osaka, Biles, and others about the crushing expectations of contemporary sports may seem new, they build on an abiding Black critique of the system. Ever since the era of racial desegregation, African American athletes have been the canaries in the coal mine of big-time US athletics, sounding the alarm about the mental and physical harm inherent in what some now call the "athletic industrial complex," a multilayered system that, as Earl Smith discusses in his book *Race, Sport and the American Dream*, generates profits off the backs of athletic laborers, with little regard for their overall health and wellness. Because of the ravages of racism and their precarious socioeconomic status, Black athletes have always borne the brunt of this system.

Today, fans have come to expect Black athletes to perform like machines, perfectly and on command for their viewing pleasure. This is hardly surprising, given long-standing US myths about African American savagery and physicality—myths carefully crafted to legitimize and uphold various forms of bondage, inequality, and violence, from chattel slavery to sharecropping to lynching to medical racism to mass incarceration. US society continues to systematically downplay Black pain. It disregards Black thought and emotions. Black athletes are expected to shut up and play.

However, this new generation of Black competitors is no longer willing to stay silent about the physical and psychological trauma of commercialized sport. Their revelations echo broader shifts in contemporary African American culture, as leading activists, artists, and intellectuals have increasingly argued that it is important to frame mental health not only as a medical issue but also as a political one. With the ubiquitous and disturbing images of Black death that spurred the rise of the Black Lives Matter movement, as well as the racially disproportionate damage wrought by the COVID-19 pandemic, activists are revisiting Black lesbian feminist Audre Lorde's notion of self-care.

Despite increasing awareness about the importance of self-care, Black women athletes, unlike their white counterparts, are rarely given the grace to show any kind of vulnerability. The public expects them to be the prototypical "strong Black woman" personified. In *Black Macho and the Myth of the Superwoman*, Michele Wallace famously dubbed this the "myth of the Black superwoman." Although it may seem like a compliment, it also serves to discipline Black women, silencing their pain and normalizing their

It is important to frame mental health not only as a medical issue but also as a political one.

exploitation, both within and beyond athletics. When confronted with ongoing racism, sexism, and economic inequality, many Black women feel compelled to project a sense of strength and control as they shoulder an unsustainable number of community, family, and work obligations with few social or emotional supports. Marita Golden notes in her book *The Strong Black Woman* that the physical and mental health consequences—racially disproportionate diagnoses of strokes, heart attacks, diabetes, dementia, depression, and anxiety—are devastating.

Given this wider context, Black women athletes should be celebrated instead of denigrated for having the courage to stop and take care of themselves. Rather than passively accepting public condemnation for her withdrawal from the French Open, Naomi Osaka penned a frank response to her critics, "It's O.K. Not to Be O.K.," in *Time* magazine in July 2021. She reaffirmed her decisions, highlighting the unreasonable demands of the industry: "I communicated that I wanted to skip press conferences at Roland Garros to exercise self-care and preservation of my mental health. I stand by that. Athletes are humans.... I can't imagine another profession where a consistent attendance record (I have missed one press conference in my seven years on tour) would be so harshly scrutinized." Osaka also faced immense pressure to publicly disclose her symptoms and her personal medical history. "I do not wish that on anyone," she said, "and hope that we can enact measures to protect athletes, especially the fragile ones."

Osaka's call for new mental health protocols did not come soon enough for Simone Biles, who defended her decision about the Olympics on social media. "For anyone saying I quit. I didn't quit. My body & head are simply not in sync," Biles posted on Instagram. "I don't think you realize how dangerous this is on a hard/competition surface." Rather than risk injury or death, the most decorated American gymnast in history chose to withdraw with her body and dignity intact.

Despite their extensive financial resources, major sports leagues/organizations have been relatively slow to provide robust mental health resources and have rarely considered changing the working conditions that produce mental illness among their athletes. Nevertheless, Black athletes are leading the charge for change. In 2021, NBC News reporter Char Adams interviewed Le'Roy Reese, professor of psychiatry at the historically Black Morehouse School of Medicine, who said, "Athletes are increasingly taking ownership of their personal narrative and making their own choices about sharing that personal narrative. There is now a sense of agency among professional athletes." As today's Black athletes, alongside Black activists, shine a spotlight on America's systemic neglect of Black minds and bodies within and beyond sports, and on the need for individual and collective forms of care, we should stop and take heed. It is important to have these conversations. It is important to reduce the stigma associated with seeking help through therapy. It is important to raise awareness and have more culturally competent counselors. For our hyper-individualistic for-profit systems are hurting all of us, even those who might seem the strongest and most capable of carrying the burdens.

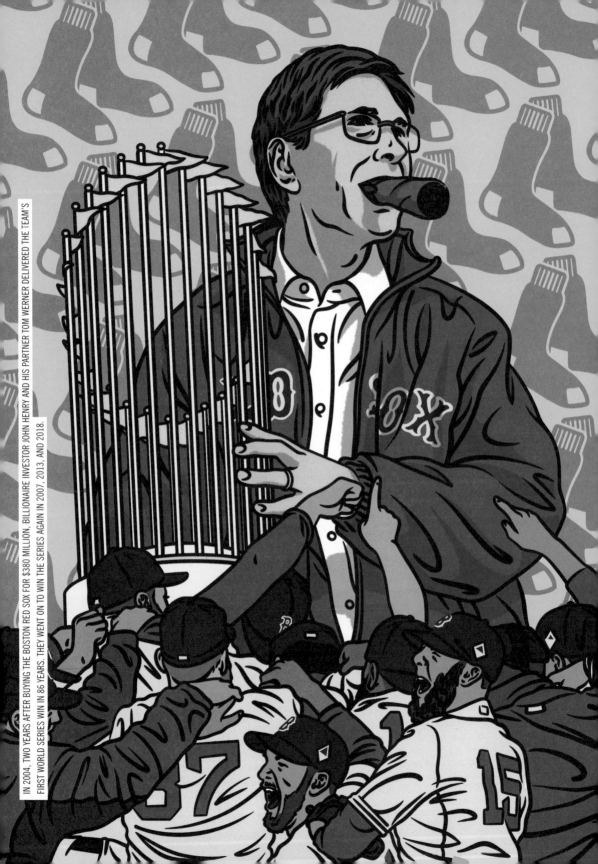

IN 2004, TWO YEARS AFTER BUYING THE BOSTON RED SOX FOR $380 MILLION, BILLIONAIRE INVESTOR JOHN HENRY AND HIS PARTNER TOM WERNER DELIVERED THE TEAM'S FIRST WORLD SERIES WIN IN 86 YEARS. THEY WENT ON TO WIN THE SERIES AGAIN IN 2007, 2013, AND 2018.

THE ANALYTICS AGE

Bruce Schoenfeld

MANY YEARS HAVE PASSED since anyone lost money on the sale of a team that plays in one of North America's four traditional sports leagues: the NFL, NBA, NHL, or MLB. For weeks, I tried to find out the last time it happened, but I still couldn't be sure. Information about these transactions is often incomplete. Debt can be involved. Sometimes, additional assets are included in the purchase—an arena, maybe, or a television network. Occasionally, through mismanagement or misfortune, ownership groups go bankrupt. But in every instance, including those involving bankruptcy, the new owners have ended up paying more—nearly always, *far more*—than the sale price the last time the team changed hands. Looking back as far as the early 1990s, I couldn't find a single instance in which the value of a franchise hadn't trended continuously upward.

That's just not something that happens with other equities. Stocks, bonds, real estate, private companies, even Impressionist paintings and first-growth Bordeaux all sell at a loss from time to time. Around the turn of the twenty-first century, as the prices for all teams (even bad ones) continued to rise, speculators who make their living buying and selling companies began to acquire them. They did it as a financial strategy, not because they were fans. As a Los Angeles–based fund manager who owns a European soccer club told me recently, "It isn't some kind of an ego trip for me. I'm just looking for a return."

This is a new development. For much of the twentieth century, sports franchises were basically toys for rich people. There were exceptions; a few owners made a living off their teams. But most bought them out of some combination of civic pride and boredom. They wanted to give back to their communities, and they needed something to do with the rest of their lives. They didn't want to go broke, of course. But most of these titans of industry weren't overly concerned about the financial success of a business that constituted a tiny percentage of their portfolio. This point was driven home to me in the mid-1990s when I interviewed Bob Tisch, the hotel magnate and former postmaster general, for a magazine article. Not long before, Tisch had purchased half of the NFL's New York Giants for $75 million. "I'm just going to pretend I never had that $75 million," he told me.

That was smart, I thought. Because as late as the mid-1990s, sports teams didn't seem like particularly good investments. Teams regularly shifted cities because of lack of support. Occasionally, they folded entirely. But that hardly mattered to the Bob Tisches of the world. Owning a sports team was like buying a winery, or opening a bed-and-breakfast on the California coast: something to do "on the back nine," which was how these wealthy capitalists tended to characterize the latter half of their careers. Many of them had been childhood fans of the teams they bought, and they ran those teams the way a fan might, making decisions based on emotion even if they were cold-hearted and calculating in their other businesses. Yet whether those decisions worked or didn't, and whether these teams were profitable and won titles or finished in last place and in the red, they inevitably became more valuable.

THE ONLY NFL TEAM OWNED BY THEIR FANS, THE GREEN BAY PACKERS HAVE A LONG-ESTABLISHED TOUCHDOWN CELEBRATION: THE SCORING PLAYER JUMPS UP THE END ZONE WALL AND IS LIFTED BY FANS IN THE FIRST ROW OF BLEACHERS. PACKERS STRONG SAFETY LEROY BUTLER MADE THE FIRST "LAMBEAU LEAP," NAMED FOR THE TEAM'S STADIUM, IN 1993.

Once professional investors started buying into professional sports at the end of that decade, the way they were run began to change. In part, this was because the prices were getting precipitously higher: from the $75 million that Tisch paid for half of the Giants to the $450 million that Joe Lacob and his partners paid for the NBA's Golden State Warriors in 2010. That kind of money demanded attention, no matter how big your portfolio. Also, investors such as Lacob, formerly a venture capitalist with Silicon Valley's Kleiner Perkins, had experienced success and failure with hundreds of companies. Over time, they developed a series of best practices to help ensure that their returns would be optimized. They used them in their other businesses, so it made sense that they would apply them to their teams.

Soon enough, a dozen of these investment bankers and money managers and hedge fund operators had bought teams across America. Then they started buying up soccer clubs in England, and around the world.

. . .

But sports teams are not quite like other businesses. And these best practices, which were probably exemplary in terms of growing a medium-term financial investment, had consequences that were not intended.

Many of those best practices involved data analysis, which was a product of the computer era. That meant gathering information, figuring out what it meant, then using it to help you make decisions. Serendipitously, data analysis, or "analytics," had just started to be applied on the fields and courts and rinks where sports teams played their games. In 2003, a former bond trader named Michael Lewis published *Moneyball*, which described how one baseball team, the Oakland A's, used the investment strategy of arbitrage—seeking out misalignments between the perceived value of assets and their actual value—to try to overcome its financial constraints and succeed on the field. Many of you reading this will know what happened after that. Analytics swept through baseball and then through other sports.

It was a triumph for all those mathematically minded fans who had spent their childhoods poring over box scores, and of information over brute force. And there is no doubt that it uncovered ways in which teams could be made more efficient. There is a reason why every major league team eventually created its own analytics department, and why the learning that emerged was applied to the decisions the teams were making, even if it was often dictated to the managers by analysts who couldn't spot the difference between a curveball and a slider.

Around the turn of the twenty-first century … speculators who make their living buying and selling companies began to acquire [teams]. They did it as a financial strategy, not because they were fans.

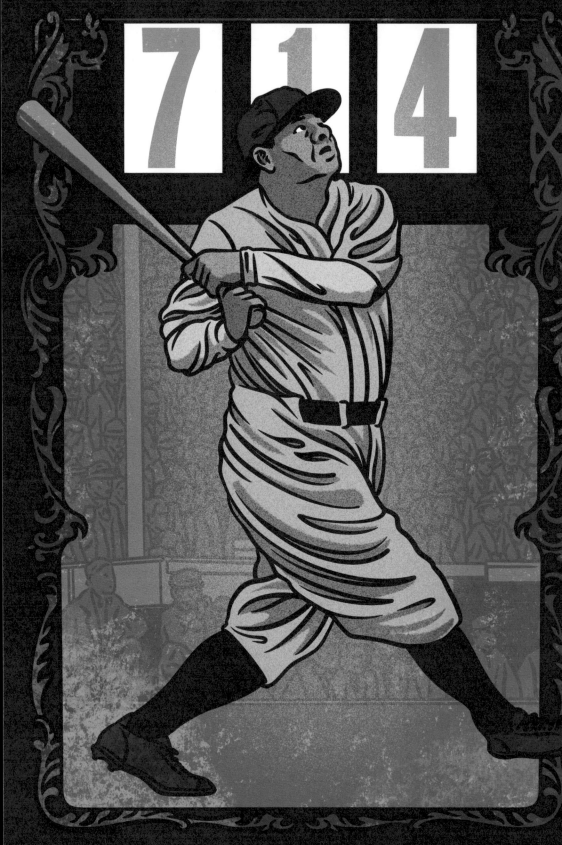

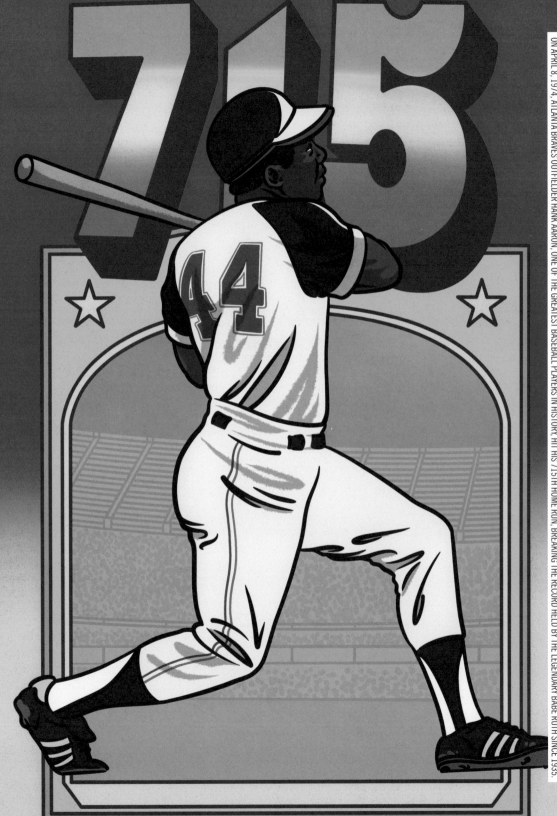

715

ON APRIL 8, 1974, ATLANTA BRAVES OUTFIELDER HANK AARON, ONE OF THE GREATEST BASEBALL PLAYERS IN HISTORY, HIT HIS 715TH HOME RUN, BREAKING THE RECORD HELD BY THE LEGENDARY BABE RUTH SINCE 1935.

How much should that data be filtered through the personal experience of executives, field managers, and players? That remained open to debate. But all of that was data, too, as Fenway Sports Group's Mike Gordon, who managed money for Fidelity Investments, liked to say. Data came in many forms, not merely from computer screens. The smartest clubs found ways to integrate it into everything they did.

Fronted by John Henry, Fenway Sports Group bought baseball's Boston Red Sox, and then soccer's Liverpool Football Club, and ultimately hockey's Pittsburgh Penguins. Henry had become rich by creating algorithms for soybean trading. He understood that data could be something of a secret weapon. At the time that his company, then called New England Sports Ventures, acquired the Red Sox in 2002, the club hadn't won a World Series in eighty-four years. It proceeded to win four of them between 2004 and 2018. Liverpool, which Fenway bought in 2010, had won eighteen English titles, but none since 1990. Instead, it had fallen far behind its rivals in the amount of money it could generate and, therefore, afford to spend. Through Liverpool, Fenway introduced to English soccer data-driven innovations similar to those it had employed with the Red Sox. In 2019, the club won its nineteenth English title. The season before, it had won the Champions League, the championship of Europe.

The part about creating revenue is important. Traditionally, even the most passionate English fans were accustomed to showing up at a game moments before it started, grabbing a meat pie and a beer at halftime, then leaving as soon as it ended. Henry and his partners knew that if they could get fans to spend more time at games, the club would end up generating far more income—from high-end restaurants, retail outlets, and other concessions. They also understood that pricing the most expensive tickets at not much more than the cheapest tickets, which was traditional in England, was underestimating how much the wealthiest fans would pay for the best seats. In short, Fenway's owners and executives looked at the club dispassionately, just as Gordon might have looked at one of the companies he was considering investing in for Fidelity, or Henry at a parcel of soybeans. Then they figured out how to make it more profitable.

It was a triumph ... of information over brute force.

What surprised the Liverpool owners, and then surprised the American owners of other soccer clubs in England's Premier League who applied versions of the same strategy in the years that followed, was how controversial this turned out to be. Like Henry, many of these owners also had teams in one or more of the four traditional North American sports leagues, which long before had standardized player introductions, musical selections, game programs, and most everything else. Paul Barber, the Englishman who runs the Premier League club Brighton & Hove Albion, described games in one of those US leagues as "marketed within an inch of their lives." Now these owners were extending that optimization to England. Going to a soccer game in England had always been a quirky, intensely local experience. Suddenly it felt like visiting the Apple Store.

Such improvements seemed foreign to English fans because they *were* foreign. "English fans put their focus on the ninety minutes of sport, versus the overall experience that North Americans enjoy around the sport," Barber explained. The whole idea of a soccer team doing much of anything besides playing soccer made them queasy, he added. "They don't particularly like the idea that their club is a business." Nobody denied that the experience of attending a game had become more comfortable. The food was tastier, the bathrooms were cleaner, the video board was bigger, the sound system was better. But in some ineffable way, the supporters of these teams believed that their relationship with their club had changed.

To these fans, many of whom had been going to games for years and almost never missed one, following their team was an emotional pursuit. It was more like practicing a religion than, say, being a customer at a restaurant, where you expected something of value in return for your patronage. Sure, your team might go a generation or more without winning a championship, and, yes, the meat pies were terrible. But that wasn't the point. Nobody goes to mass, an Irish friend of mine once told me, because the wafer tastes good. For data-driven owners operating off spreadsheets, such illogical devotion was hard to understand. And it was almost impossible to quantify.

This new generation of owners deserves credit. It has been smart enough to transform sports teams from small companies that sold a single product into some of the most advanced businesses in the world. But like everyone who buys and sells for a living, their mandate is to grow the value of their assets and turn a profit, a mentality that doesn't always take sustainability into account.

. . .

By then, the close connection between fans and the teams they followed had started to fray in North America, too, but for a different reason. As early as the late 1980s, the proliferation of fantasy leagues started to redefine what it meant to be a sports fan in America.

Traditionally, fans had an affinity for particular teams. The reason was often geography, but it could be a favorite player (as with much of the African American community and Jackie Robinson's Dodgers) or even a uniform detail (the lightning bolt on those San Diego Chargers helmets). If you were a Yankees fan, you watched them when they were on television. If you lived close enough to New York, you listened to games on the radio, followed them through newspaper accounts, and went to Yankee Stadium when you could manage. Maybe you liked Reggie Jackson even more than you liked the Yankees. If so, in 1982, when his contract expired and he signed with the Angels, you might have become an Angels fan. But if you weren't rooting for one team, you were rooting for another.

In the ad hoc fantasy leagues that eventually morphed into daily contests with cash rewards that were run by gambling companies, the team you were rooting for was *your* team. It was a team you had constructed under various parameters, including how much money you could allocate to acquire players, each of whom had a set value. Fantasy was fun because you became a participant—not merely an observer of others winning and losing, but a winner or loser yourself. But the relationship couldn't help but feel transactional.

In 2018, a Supreme Court ruling allowed states to legalize sports gambling. In many states, you now can use your smartphone to bet on the game before it starts and even as it progresses. You can bet on which team will win, but also on increasingly baroque offerings such as which player will score the most points in the third quarter. In those instances and many others, you're rooting for outcomes within the fabric of a game of which even the participants—the players themselves—might not be aware. Curiously, the owners and the leagues don't mind any of this. In fact, they encourage it. The greatest way to grow the NBA, I was told by Adam Silver, its commissioner, was to get fans who already were watching basketball to watch each game just a bit longer. And the best way to do that? Get them interested in something more than the final score.

As time passed, the modes of following sports have become like stock market derivatives, further and further removed from the outcomes of the games. In August of 2023, the Tampa Bay Rays hosted a virtual tournament in a baseball video game. The two finalists were flown to Florida to contest the championship live on a big screen. Those games, sent out on a Twitch feed, even had a brand name: the Sunburst Classic Championship. The winner left with bragging rights—and $8,000. The Rays had invented a sports event tied to their baseball team that didn't involve players or coaches or an opponent, merely a simulacrum of each of them.

This new generation of owners deserves credit. It has been smart enough to transform sports teams from small companies that sold a single product into some of the most advanced businesses in the world. But like everyone who buys and sells for a living, their mandate is to grow the value of their assets and turn a profit, a mentality that doesn't always take sustainability into account. This may eventually uncouple the relationship between fans and teams. But whether sports events will even exist in twenty years is not necessarily relevant for someone who plans to cash out in ten.

The car dealers and shopping mall magnates who once owned teams rarely thought even that far ahead. They were not visionaries, and there was nothing baroque or transactional about their relationship to sports. They would sit in their seats with a hot dog, and root for their team to win the game.

THEY MADE ME DO IT

Seph Rodney

I N THE LATE 1990S *Sports Illustrated* featured on its cover a street basketball player who went by the name Booger. I first came to know about the Brooklyn-based point guard through this cover story, "Asphalt Legends" by Rick Telander, which ran on August 18, 1997. The article profiled athletes, including Booger (born Edward) Smith, who were defining a new urban amateur athlete phenomenon in the United States: streetballers. The story was published at a time when the streetball game was proliferating around the country, led by the AND1 footwear and clothing company, which in 1999 started a series of summer tours with a roster of traveling streetball legends (including Grayson "The Professor" Boucher, who still tours, and Rafer "Skip 2 My Lou" Alston, who made it to the NBA).

The streetballers' game had a lot of flash: no-look passes that were a blur, dribbling the ball between the legs of embarrassed defenders, or dribbling the ball off the same defender's head, alley-oops for days. And part of the stylistic drama that made these players extraordinarily popular was how they made it all look effortless. Booger would casually fake a drive and then change direction so fast that inertia would lurch his defender off his feet like a drunken sailor. One thing Booger said has stayed with me, more than his

moves, since I first read it over twenty-five years ago in "Asphalt Legends." Telander quotes Kenny Jones, the coach who took in a sixteen-year-old Booger to live with him while also coaching him as a player for the Kenny's Kings team:

> The remarkable thing about many of Booger's moves is that he cannot replicate them off the court. They are unplanned, unpracticeable responses to stimuli. A hoops magazine asked Booger to do a couple of things for its cameras last year, and he failed miserably. "Once I asked him after a game, 'Where did you get that move?'" recalls Kenny Jones. "And he said, 'They made me do it.'"

This is the beating heart of athletic contests—all of them, I would argue, regardless of structure, gender or ability of the players, or the field of play: that your opponents *compel* you, the player, to find and activate the parts of you that are otherwise hidden, even from yourself. This unspoken aspect of sports undergirds the entire *Get in the Game* exhibition, which aims to showcase the astonishing grace, the daunting sacrifices, and the bitter humor that greet both the triumph and inevitable losses that play out in organized public athletic competitions.

The urgency and high stakes of the contest often impel both participants and audience to refer to it as a battle, as warfare. This hyperbole is warranted. We tacitly agree to treat games as important enough to hazard players' health and even wager their lives. I think of the boxer Duk-koo Kim, who collapsed into a coma after fourteen punishing rounds in his 1982 boxing match with Ray Mancini. At age fifteen, I was just starting to be interested in the sport. I didn't see the fight but read about it after and was horrified. Kim died five days later in the hospital of a massive subdural hematoma, and both his mother and the bout's referee committed suicide in subsequent months. In war, some soldiers die on the field.

One contest I did see televised was US gymnast Kerri Strug competing in the women's all-around team competition for the 1996 Summer Olympics in Atlanta, Georgia. Entering the final rotation, with the US holding a significant lead over the Russians, who were and are the nation's perennial rivals on the world stage, Strug injured her ankle during the first of her two vaults in her final event of the competition. The vault requires athletes to run forward at almost full tilt, stomp on a springboard to launch themselves hands-first onto the vaulting apparatus, and then fling their bodies into space, twirling, turning, a small gyroscope secreted in their sternums allowing them to land on their feet without hops or skips. Strug

It might be in you to want
to hurt someone just as
much as you are hurt by
the prospect of losing. It
may be in you to give your
all until your body fails.

completed the second vault because, so the story goes, the team needed it to beat the Russians. She stuck the landing, hopped onto one leg, and then collapsed to her knees, the pain eroding her smile into a grimace that gymnasts mostly hide. She was hurt so badly she had to be carried off by coaching staff. Her team did beat the Russians for the gold medal, though she was diagnosed with a third-degree lateral sprain and tendon damage, making it impossible for her to compete in the individual women's all-around competition and event finals. She knew she was injured and yet put herself at greater risk. Why? Because of the game: the god that tells you that if you want the promised land then you must sacrifice yourself, the coaches who open you up and pour their faith into you, the brother and sister at home who idolize you, the fans who want desperately to be you. They make you do it.

Beyond the secretive and capricious demiurge of sport that impels you to place yourself on the altar, the coaches are the bellows stoking the fire that was inside you all along. They speak to you at every practice, at every game, each a hierophant divulging the secrets of excellence. My own coach, who taught me foil fencing at the McBurney YMCA in New York's Chelsea neighborhood in the 1990s, would tell me that my parry-riposte with a one-two wasn't working because I rushed the lunge. He'd remind me that he'd seen me hit other fencers with that move in practice bouts. He spoke to me as if he knew my potential better than I did. I believed him because there was no one else in my life at the time who paid as much attention to my body's capabilities, no one else who seemed so invested in what I could become. It's because of the intimacy of this relationship that coaches' abuse of their charges may feel like a devastating betrayal to players and those close to them. Few people have access to this fragile part of your being.

The vault requires athletes to run forward at almost full tilt, stomp on a springboard to launch themselves hands-first onto the vaulting apparatus, and then fling their bodies into space, twirling, turning, a small gyroscope secreted in their sternums.

It's also the parents, and the friends in the stands, all the spectators who *make* you do it: reach back behind your head as your body bows like a fishing rod, and your hand shoots out, your fingers racing to hook the catch racing away from you, while a defender tries to pull your left arm back toward him as you take two more faltering steps and leap into the air for the football falling from the sky like a talisman that might save your life. You find it and grab it with one hand. You've never done this before, but you dreamed you could. The cornerback trying to thwart your catch compelled you to bring that fantasy into waking life. When, on a Sunday in November of 2014, I saw Odell Beckham Jr., then of the New York Giants, make that touchdown reception against the Dallas Cowboys, I understood that professional athletes are not really ever overpaid. They can't be. They are the human vehicles who make our own dreams seem possible, almost available to the touch.

Athletes make these offerings to who they think they might become long before they enter the arena. A few years ago I read about the British cyclist Chris Hoy, who is the second most decorated Olympic cyclist of all time. According to the reporter Ian Stafford, Hoy described his interval training sessions this way:

> The lactic acid builds up in your legs until, in the final minute or so, your muscles begin to shut down. When the session is over, people have to unclip me from the bike, ease me out of the saddle and lay me down on a padded mat. If it is painful during the interval session, it is nothing compared with the pain that immediately follows. . . . Every time, you think it's worse than ever. Every time, you convince yourself that something's wrong, you must have a virus, or you're ill, or something. You have pretty much decided you're not going to do it again—ever. Then after 15 minutes, almost to the second, the pain subsides, you sit up, start talking and get on with it.

This is the rider of every contract a competitor signs explicitly, or tacitly, with their mouths or with a pen, with their own hand or via an agent. They sign and commit to showing up for each training session whether it's beautiful weather out or a blizzard, to practicing on weekends, to giving up family time. I gave up meeting friends at the Coney Island boardwalk, instead choosing to stay in the gym, just me and the coach and my flailing arms and legs trying to get the parry-riposte right.

There's a famous quote attributed to UCLA Bruins football coach Henry Russell "Red" Sanders: "Winning isn't everything; it's the only thing." This is a lie. Failing is also a thing that happens. Losing is almost always an option. And this is something that artists know intimately: the work can fail to make the kind of meaning you wanted desperately for it to make, fail to be beautiful in a way that doesn't seem cliché, or derivative, or contrived. Artists have to contend with themselves and with every other artist who makes similar work within a field of play—an entire history of making that has preceded them, that has already made certain strategies or gestures seem obvious, uninspired. And they too have coaches, or mentors. They have fans and those who idolize them. They have sisters, brothers, and cousins who want to live their lives. They know, as curators, dealers, critics, and patrons know, as we who have organized this exhibition know: we may not succeed in the game we've decided to play.

When we do fail, sports make us feel miserable about ourselves. Those who adore both sports and art (and those who are largely indifferent to them) don't talk much about this: how the game and all involved can make you suffer, make you wonder whether you'll be anything that is memorable in the world if you can't get just this one thing right. The game can put you in a depression for days, or months. It can also make you a little mean and a bit brutal.

Sports bring out what is in us to meet the challenge of the moment. It might be in you to want to hurt someone just as much as you are hurt by the prospect of losing. It may be in you to give your all until your body fails. Others have found that they have to leave because the game is too demanding mentally and physically. When your champion loses the game, the set, the match, do you imagine (perhaps correctly!) that the contest is rigged, that *they* won't ever let you win? For me, sports have always been all of the above, especially coming to understand that I would never be a great basketball player, or even a good one. When I figured out that I didn't have the quickness, the aggression, the sense of the possibilities of a ball being moved around a half-court set among five players, didn't have the eyesight to make a capable shooter, I gave up the game and devoted myself to fencing, something I was marginally better at. I needed to find a way to glimpse something beautiful inside myself.

When I was fencing competitively in Southern California in the 2000s I was only a mediocre fencer on the piste (playing area), though I was good in practice at the salle (fencing school). Being onstage made me nervous. I likely would have benefited from medication, something to help me keep the fear of failure at bay. But I didn't have that, and

never got further in the rankings than a C. But there was one bout where I saw my opponent practicing drills with his coach. He looked intelligent, poised, precise. I had no idea what would happen. Typically when I fenced I would yell out when I made a touch—something like a "Whoooo!" This is instinct, and also a release of all the pent-up nervousness and fear and expectation. I started fencing him. He had a complicated system of defense—lots of circle parries. Somehow I figured it out and there was a moment I was on the attack, stretched out my arm, and saw his parry coming. Time slowed down. I knew what I had to do. I was already yelling when I could see the touch happen even before it landed. He, his coach, the bout referee, all the people who had ever defeated me made me do it. I would not have gotten there without them. And now I think, as tears start in my eyes, how will I know again this best part of myself outside of the piste, that moment of test and challenge?

One answer is my turn toward curatorial work and more specifically the construction of this show. I gave up fencing when I moved to London in 2006 to work on my doctoral degree, donating all my equipment to my last fencing club, the Couturier salle in Culver City, California. Since then I've not participated in many sports competitions, preferring the deeper satisfaction of using my energy to parse, study, and argue over the meanings of visual art. In other ways artists make me do it: wonder, speculate, investigate, and discover. The leaps of insight they devise make me want to put them all in a room together where the ideas that undergird their work connect and amplify each other so much that everything seems to be in motion, and my feet don't touch the ground. All of us who have helped make this exhibition live in our waking lives—particularly my co-curators Katy Siegel and Jennifer Dunlop Fletcher—are similarly buoyed by the varied meanings these artists show us can be had in sports. At every turn of *Get in the Game*, we are saying to each other, "Wow. You've *got* to see this."

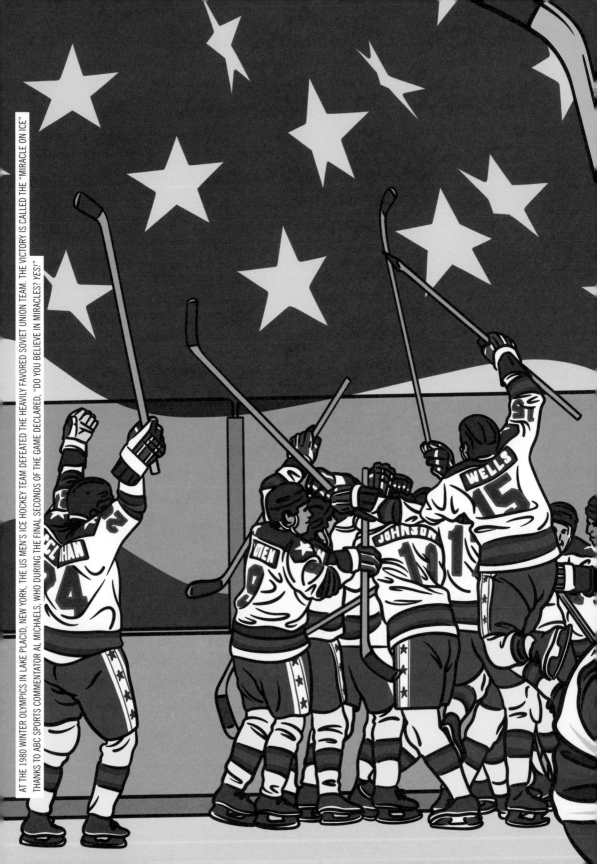

AT THE 1980 WINTER OLYMPICS IN LAKE PLACID, NEW YORK, THE US MEN'S ICE HOCKEY TEAM DEFEATED THE HEAVILY FAVORED SOVIET UNION TEAM. THE VICTORY IS CALLED THE "MIRACLE ON ICE" THANKS TO ABC SPORTS COMMENTATOR AL MICHAELS, WHO DURING THE FINAL SECONDS OF THE GAME DECLARED, "DO YOU BELIEVE IN MIRACLES? YES!"

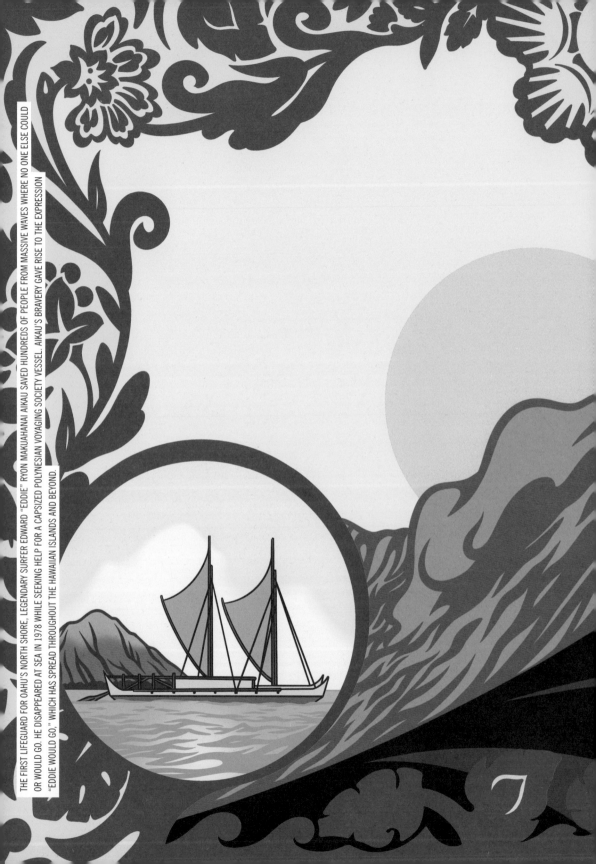

THE FIRST LIFEGUARD FOR OAHU'S NORTH SHORE, LEGENDARY SURFER EDWARD "EDDIE" RYON MAKUAHANAI AIKAU SAVED HUNDREDS OF PEOPLE FROM MASSIVE WAVES WHERE NO ONE ELSE COULD OR WOULD GO. HE DISAPPEARED AT SEA IN 1978 WHILE SEEKING HELP FOR A CAPSIZED POLYNESIAN VOYAGING SOCIETY VESSEL. AIKAU'S BRAVERY GAVE RISE TO THE EXPRESSION "EDDIE WOULD GO," WHICH HAS SPREAD THROUGHOUT THE HAWAIIAN ISLANDS AND BEYOND.

TOP TEN REASONS WHY INDIANS ARE GOOD AT BASKETBALL

Natalie Diaz

1.
The same reason we are good in bed.

2.
Because a long time ago, Creator gave us a choice: You can write like an Indian god, or you can have a jump shot sweeter than a 44oz. can of government grape juice—one or the other. Everyone but Sherman Alexie chose the jump shot.

3.
We know how to block shots, how to stuff them down your throat, because when you say, *Shoot*, we hear howitzer and Hotchkiss and Springfield Model 1873.

4.
When Indian ballers sweat, we emit a perfume of tortillas and Pine-Sol floor cleaner that works like a potion to disorient our opponents and make them forget their plays.

5.
We grew up knowing that there is no difference between a basketball court and church. Really, the Nazarenes hold church in the tribal gym on Sunday afternoons—the choir belts out "In the Sweet By and By" from the low block.

6.
When Walt Whitman wrote, *The half-breed straps on his light boots to compete in the race*, he really meant that all Indian men over age 40 have a pair of vintage Air Jordans in their closets and believe they are still magic-enough to make even the largest commod bod able to go coast to coast and finish a layup.

7.
Indians are not afraid to try sky hooks in real games, even though no Indian has ever made a sky hook, no Indian from a federally recognized tribe, anyway. But still, our shamelessness to attempt sky hooks in warm-ups strikes fear in our opponents, thus giving us a mental edge.

8.
On the court is the one place we will never be hungry—that net is an emptiness we can fill up all day long.

9.
We pretend we are playing every game for a Pendleton blanket, and the MVP gets a Mashantucket Peqot-sized per capita check.

10.
Really, though, all Indians are good at basketball because a basketball has never been just a basketball—it has always been a full moon in this terminal darkness, the one taillight in Jimmy Jack Tall Can's gray Granada cutting along the back dirt roads on a beer run, the Creator's heart that Coyote stole from the funeral pyre cursing him to walk alone through every coral dusk. It has always been a fat gourd we sing to, the left breast of a Mojave woman three Budweisers into Saturday night. It will always be a slick, bright bullet we can sling from the 3-point arc with 5 seconds left on a clock in the year 1492, and as it rips down through the net, our enemies will fall to their wounded knees, with torn ACLs.

Natalie Diaz, an enrolled member of the Gila River Indian Tribe, is a Pulitzer Prize-winning Mojave American poet, language activist, and educator, and has played basketball professionally in Europe and Asia. This poem appears in her collection *Postcolonial Love Poem* (Graywolf Press, 2020) and is reprinted by permission. Additional credits appear on page 164.

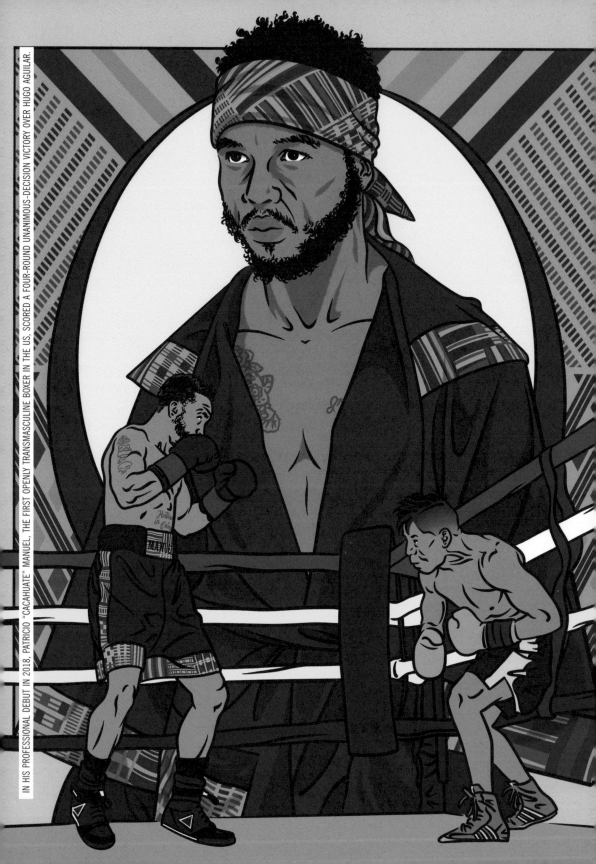

SO MUCH BEAUTY, EVEN WITH THE VIOLENCE

Patricio Manuel & Meg Onli

Meg Onli: As a curator, one of the things I've been thinking about this past year has been the sudden focus on trans art and trans aesthetics, as if that's something that can be defined. But I think that's as complicated as identifying Black aesthetics or Black art. The art world is often trying to package things, and I find it's contrary to some of the politics and ideas behind queer and trans embodiments and acknowledging pluralities of self. As the first transmasculine professional boxer, is this something you're thinking about? I know you're constantly being approached, not only to speak on behalf of, let's say, your community, to cis people within boxing, but also to speak back to trans boxers who now want to box because of you.

Patricio Manuel: Well, that's an easy question. I mean, I don't want to speak for everyone, obviously, because that's something we're trying to get away from. But let me say for myself, I think there is always a risk of dehumanization, and I think it's layered when you're Black and trans and an athlete. So much of the conversation around representation and visibility does feel like a form of commodification. When people approach me, it's often like, "Oh, now

In boxing
there is a real
intelligence,
depth, and poetry.
It's called "the
sweet science"
for a very specific
reason.

—Patricio Manuel

we can show that we've got a Black athlete and a trans athlete."
There can be a lot of resentment around not being seen as our full
selves because we get niched down into which identity boxes can
be checked off.

MO: I'm really interested in this idea of the instability of self, how
it's undefinable. A lot of my work has been preoccupied with the
idea that language fails us, and in particular fails in naming us—fails
in naming me, let's say, as a queer Black person. There is a way in
which that label fails to name so many other things about me.
You've talked about what it means to be not just a Black man and
a Black trans man but also an athlete. I think there's also a histor-
ical context to that. Can you say a little bit about the position of
the athlete and specifically the position of the boxer historically?
PM: If we're talking about the American context, boxing is such a
historical sport, literally dating back to the original Olympic Games
in Greece. But let me start with the first part of your question. I
think athletes hold a dual identity in society. Clearly they are put on
a pedestal. And ideas around motivation and discipline are often,
sometimes very incorrectly, wrapped up in an athlete's identity.
At the same time, because athletes are primarily recognized for
what their bodies can do physically, they're often seen only from
that perspective.

There's very much this idea that athletes are dumb, or shouldn't
be involved in issues that have depth. With LeBron James and Colin
Kaepernick, for example, there was this sense that they shouldn't
be involved with protests and should focus on their sport. In the
art world, whether it's actors, or artists, or other types of perform-
ers, I feel like there is much more latitude to have an intellectual
identity, whereas an athlete is thought of only as a body. Boxers in
particular, we're seen as the dumbest of the dumb, because most
people don't have an understanding of combat sports.

In boxing there is a real intelligence, depth, and poetry. It's called
"the sweet science" for a very specific reason. It is poetry in motion.
Boxing isn't just about blindly throwing your fist; it's about being
able to control yourself and being able to move your body against
the body of another skilled fighter. There's so much beauty in it, even
with the violence. But a lot of the time we get really degraded, and
are not seen as people who are capable of any sort of intellectual
conversation.

I think so much about this as a Black person. Boxing is the sport of the oppressed. It has consistently been a space for those from ethnic groups who do not have other opportunities to literally fight their way into a position of wealth or power, or even just into having a voice and being respected in their community. And that is often seen as a purely physical achievement. People rarely see that boxing and athletics as a whole are actually about a combination of intellectual and physical strength and emotional fortitude.

MO: You've been boxing for over twenty years, so I've had a chance to see you compete in many different situations, and to witness the dehumanization that happens in sports—and not just in combat sports. I'm now thinking particularly about football. I would say that sports with players who are not predominantly white tend to have this mentality of "kill him" or "stop complaining, get up and play." As if the players are not actually people. I think this comes back to the way in which Black and brown bodies are often deemed less-than and codified as objects. That's one of the most disturbing things I see when I'm in the audience.

A lot of people ask me what it's like to watch you box. It makes me very nervous, but you are so in control of your body. I think there's this way in which people watching boxing just assume it's easy. But to be able to throw a punch and have power and accuracy behind it is incredibly difficult. I think one of the really beautiful things about boxing is the respect all of you have about what it means to get in the ring and really go toe to toe. You've been very vocal about the relationships between athleticism and ability. There is this myth that the athlete is the end we should all be striving for, without understanding (a), the dedication and control, money, and time it takes to be dedicated to your body in that type of way, and (b), the toll it takes on you. Will you talk a little bit about the combination of performance and ability it requires?

PM: I always like to say to people that every athlete is a disabled person. I'm not talking about recreational sports. I'm talking about people who—whether it was at an amateur level, a collegiate level, or a professional level—have had a long-term involvement in a sport. Every athlete competing at a high level is specializing in a movement that is not natural to humans, and there is pain that comes with that. I don't think people understand that unless they've actually spent time really dedicated to a sport. The human body is not meant to spend five to six hours a day, six days a week, being pushed to levels that the average person has no idea about.

There are long-term consequences, and I'm not even talking about cognitive consequences. I'm talking about your body and its ability to move. And there is very, very little safety net or financial compensation. I don't think most people realize that to be an athlete, you're usually paying to play. People sit back and watch and marvel at what athletes are able to do, but they don't realize how much we pay in the long term for those brief moments of glory.

MO: There has been a gap for me in seeing the difference between the two of us in terms of class and our relationship to our jobs and the things we do. There is such a long track on which I get to do this job, but for most athletes it's a very small window. There's such focus and drive and love and dedication to something that will not be there in the long term. I mean, you can obviously stay involved within the community. But there's such a finite time that you have a chance to actually compete, and it takes such a toll.

I also want to talk about your connection to the art world. Since you've transitioned and have been boxing professionally, you've had lots of photographers follow you over the years. Wally Skalij, for example, has followed you, profiling you in the *Los Angeles Times*, but as you turn pro, you have been collaborating with the photographer and contemporary artist Texas Isaiah, documenting your performance in matches as well as the interstitial times. Your work together is modeled after a series Gordon Parks did with Muhammad Ali for *Life* magazine. What brought the two of you together for that, and what has the experience of being photographed by Texas Isaiah been like?

PM: Yeah, I feel very spoiled, especially as a trans person. I think trans bodies are often so sensationalized and, actually, I have had so many great relationships with photographers, even prior to Texas Isaiah—people who were cisgender and white, some straight, some not, who really respected me and gave me a lot of agency and control over being photographed. I will still say, despite all that, there is something, for lack of a better term, magical about being viewed and being seen by someone who actually understands you from an internal, spiritual place: to be Black and trans and to be photographed by someone who is Black and trans.

I didn't want to be the first. I've never been interested in claiming that kind of title. But I will say as someone who loves the sport of boxing and particularly the Black history connection, particularly in the US, it felt very, very fitting that a Black trans person got to be one of the first, as opposed to a non-Black person. Because so many of the firsts in trans sports have been about white people being uplifted. I think there is something to be said about having that moment documented and viewed and perceived by a Black trans person. I feel you can see that when you look at the photography that has come out of our working relationship.

There's no trans person who hasn't experienced rejection and oppression. That's just the way it is. But I've also been so embraced in the sport because this community watched me grow up. There is something incredibly intimate and personal and humanizing about seeing a boxer in their corner, preparing to enter the ring. There is not one boxer I know who doesn't talk about the extreme isolation right before the bell rings, when it's just you in your corner. This is a sport where people die. That's the reality of it. I have seen people not come back from a knockout. I have seen people, whether they

passed away or they went into a coma or they were physically never the same type of fighter afterward . . . the stakes are incredibly high. You have to be completely prepared for going into combat. I feel like the preparation before you go into matches, it's a deeply spiritual ritual because you're steeling yourself for the possibility that you will not leave the ring. So there's something about being so present and being so disciplined and being prepared by your corner. To have someone documenting those moments, that is something special.

MO: In looking at Gordon Parks's photos I found an image of Ali's knuckles. It's like they're scratched. They've also been molded. One of the things I often tell people is that when you and I were growing up, a lot of people thought we were twins. Transitioning has obviously shifted some of your features, but your face has also been shifted by the sport. There are places where it's like I'm seeing the punches themselves.

PM: I'm a fighter. At the end of the day, that's the thing I will always be proud of. But as someone who is thirty-eight years old, I've really reflected on what it has meant to sacrifice a large chunk of my athletic prime in order to transition. I look to Muhammad Ali as someone who also lost his prime, because of his choice to be a conscientious objector. He had to rely so much on his intelligence because by the time he came back, he didn't have the same type of zip and spring. I really try to lean into that lineage and that history of remembering, yeah, I may have lost these years because I chose to transition, but I have a world of experience and I have listened to and sat and watched so many great boxers fight. I can leverage all of that and see just how far I can go.

✦

Patricio "Cacahuate" Manuel, a five-time amateur boxing champion, is the first openly transmasculine boxer to fight professionally in the United States. He is Meg Onli's brother.

Meg Onli is a curator and writer and is currently curator-at-large at the Whitney Museum of American Art, New York. She is Patricio Manuel's sister.

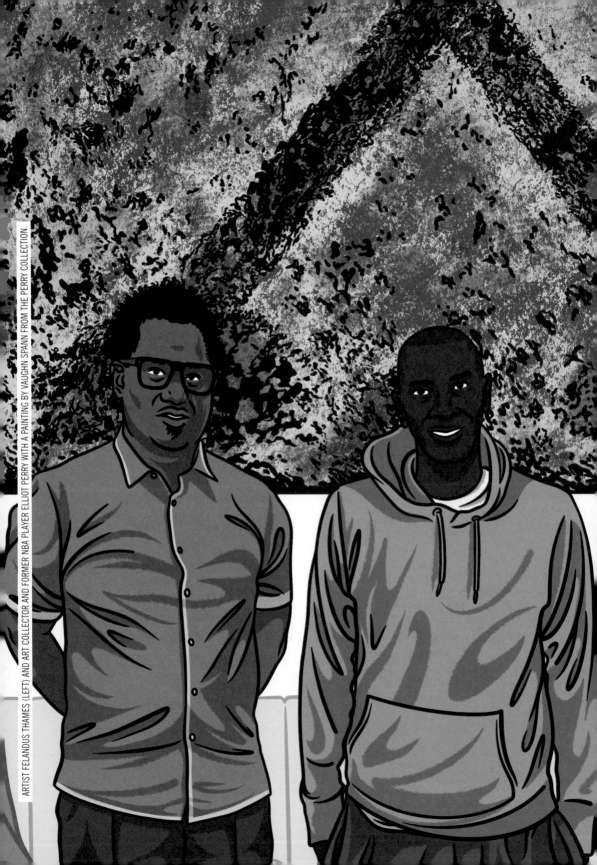

REVEL
IN THE
RELATIONSHIPS

Felandus Thames & Elliot Perry

Felandus Thames: Brother, our first interaction feels like it was yesterday. I remember I was outside the Whitney Museum when you called, and I instantly recognized who you were because I'd grown up watching you ball next to one of my favorite players. During our brief exchange I unpacked ideas surrounding a painting of mine that you were considering acquiring. The conversation wasn't long, but I was assured that you are not a pedestrian collector.

It's fascinating to see athletes becoming more involved in the arts. I recall, a couple of years prior to our conversation, being completely captivated by the depth of Grant Hill's collection. I later stumbled upon an article featuring Patrick Ewing's paintings that mentioned he had studied art at Georgetown. Thinking of these makes me curious about your personal journey. How did you first become interested in art, and, more specifically, how did you find your way into collecting?

Elliot Perry: Charles Barkley took a group of us to Japan back in the summer of '96 for nine days to play three exhibition games. And on that fifteen-hour flight, I sat with Darrell Walker, and he was pulling out these catalogues and talking about art. I didn't know anything about it. Bernard King was my favorite player—Darrell

played with him in '83, his rookie year—and he had gotten Darrell into collecting. King had one of the foremost collections of African American art in the country. I just listened to Darrell talk about it the whole way to Japan and back.

When the season started that fall, Darrell would look at our schedule and he'd see I'd be in New York or Boston or Houston or wherever. He would call me and say, "Hey, this exhibition is showing; go to this museum" or "Hey, let me connect you with this or that local artist." And so I would drop my bags, jump in a cab, and go to museums, to galleries, to artists' studios. And he was always sending me catalogues and books, so I was reading a lot.

Then in summer 1997, I went to see an exhibition, near where Darrell lives in Little Rock, of the collection of Dr. Walter Evans. This was mind-blowing for me because Dr. Evans had works by all the people I was reading about—Elizabeth Catlett, Jacob Lawrence, Romare Bearden, Charles White. I mean, you name them, and he had the best of those works. So when I saw that collection, I thought to myself, "This is what I want to do if I'm going to collect for the next thirty, forty, fifty years." I started collecting that summer.

And then in 2004, I was reading the catalogue from that Evans show, and something stood out that I hadn't noticed prior. He said, "I wanted to do three things in the early '60s. I wanted to support emerging artists; I wanted to establish a relationship with those artists; and the last thing I want to do is collect the works." And I thought, "Man, I can do that." And so I did a one-eighty and started only collecting works by living artists.

FT: Speculative collectors are playing a significant role in the rise of contemporary African diasporic art on the world stage. As a person who lives with your collection, could you unpack your role as a support system for artists and as a steward of the works you've acquired?

EP: We were acquiring many of the artists in our collection before they became well known. My wife, Kimberly, and I look at a lot of art, and we've pushed ourselves as collectors to get out of our comfort zone. I think the difference is that we want to protect the culture in a lot of ways but, also, there's not one artist I haven't reached out to before we collected their work. I always tell them, "I want you to be comfortable. I want this to be a partnership. I want to tell you about what we are trying to accomplish, so that you see your work going into a collection that's more than just transactional."

I want to tell you about what we are trying to accomplish, so that you see your work going into a collection that's more than just transactional.

–Elliot Perry

FT: Brother, your collection is on par with those of many small museums I've visited. But lately I have been hearing rumblings around the art world about prominent Black collectors having limited access to the work of Black artists represented by mega-galleries. Have you encountered this too?

EP: This question is very relevant and there are many elements that come into play here. Yes, I have experienced difficulties getting access to works by African American artists represented by top-tier galleries, and of course it's frustrating to not be able to see available works. I do realize that when demand is high and supply is low, certain folks get prioritized—usually top collectors (who are mainly white collectors and those with existing relationships with the gallery) and museums. And a lot of galleries become protective or territorial because of the economics (like rising prices) of the industry.

FT: Right, right. Okay, so you are the very first NBA player to have played with a conceptual artwork. You had a statement on your socks—

EP: "The confidence is the key."

FT: Yes.

EP: Yeah, I wrote that on my kneepad in college because I was struggling in my junior year, and I got that statement from a *Sports Illustrated* article. This writer said something like, "If you take one thing away from a great player, he becomes average. And if you take an average player and you give him this one thing, he could become great." And that thing was confidence.

FT: I think, to be a great collector, you have to have confidence in your eye. How do you educate yourselves to make better decisions about what you're going to live with, what you're going to collect, which artists you're going to steward? Do you see a through line of what you're interested in?

EP: The through line for us is really being brave as collectors. I can't tell you before I see it, but when I see it, I know why I am collecting a certain artist. Again, we look at thousands of works. I look at art every day. That's why I trust my own instincts, and I don't lean on what is trendy. I want to be remembered as someone who can say, "I jumped, and I'll figure out where I'm going to land in the air." I'm not worried about who is validating an artist's work or what gallery they're with.

I also think it's important to form relationships with like-minded collectors, so you're not in isolation. For us, this "support group" is Darrell Walker, AC Hudgins, Anita Blanchard, Pamela Joyner, and Darryl Atwell. We share information, openly express our opinions about works we like or dislike, and genuinely encourage each other.

FT: Would you mind speaking a bit about your role as mentor to other people in the sports world who are cultivating an interest in collecting?

EP: I had early conversations with [sports agent] Rich Paul when he started acquiring art. I wouldn't say I necessarily mentored him, but I gave him some familiar names to look at and gave him some stuff to read. There's also Jerami Grant, who's doing a good job of starting to build a collection; Derrick Rose is too. We've had ties, Darrell and I, one way or another, with all of these guys, just being a resource. What I tell most collectors is, "Don't just look at what I'm collecting. Look at a lot of artwork because you're going to build your own eye." It's also important to read a lot and, if you can, to talk to the artists. Make sure that you build your own taste in terms of what you're collecting, because you're the one who's going to have to live with the work.

FT: As a ballplayer, you have to take into account the scouting report: "This guy doesn't like to switch on a pick" and "That guy rolls off the screen this way or holds for separation" and "This guy generally pulls up after the screen, or fakes the pull-up before the hesi, crossing over and slashing to the basket." Are there strategies like this from your athletic journey that you feel translate to your collecting?

EP: Thinking about scouting reports, one of the things I love to do when I see an artist I really like is look at the work they were making five years before and five years after the piece I'm interested in, so I can see a kind of trajectory and growth.

But ninety percent of collectors, I would say, are going to wait for somebody to tell them what to buy.

FT: They buy with their ears instead of their eyes.

EP: Right. And so my job is to work hard, look at a lot of artwork, and trust and depend on my eye. Go back and look at what that artist was doing before. And I think one really important strategy for us is to connect with artists early, through the MFA programs, and develop relationships. What I just kind of revel in more than anything else is that I have a personal relationship with every artist whose work is on the walls of my house. I can pick up the phone and call every artist whose work I'm looking at right now, and that's so important.

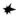

Felandus Thames is a conceptual artist living and practicing in the greater New York area. He aims to create work that functions in the way that Black music is endowed by, but not the sum of, Black joy, pain, and suffering.

Elliot Perry is a former professional basketball player and part owner of the Memphis Grizzlies. He and his wife, Kimberly, have been collecting art and establishing relationships with preeminent contemporary African American artists for more than two decades.

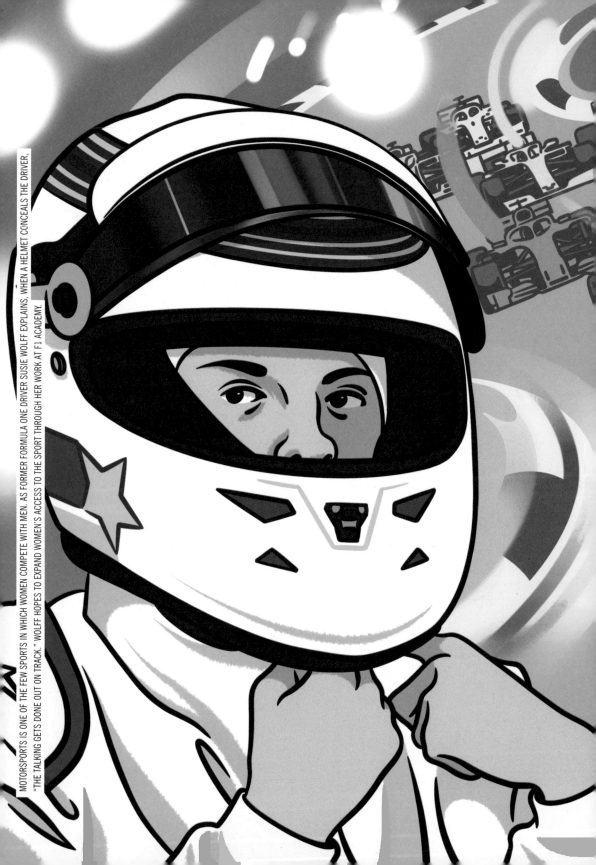

MOTORSPORTS IS ONE OF THE FEW SPORTS IN WHICH WOMEN COMPETE WITH MEN. AS FORMER FORMULA ONE DRIVER SUSIE WOLFF EXPLAINS, WHEN A HELMET CONCEALS THE DRIVER, "THE TALKING GETS DONE OUT ON TRACK." WOLFF HOPES TO EXPAND WOMEN'S ACCESS TO THE SPORT THROUGH HER WORK AT F1 ACADEMY.

I LOVED SPEED, I LOVED ADRENALINE, AND I LOVED COMPETITION

Susie Wolff & David Sze

David Sze: I'd love to hear how you got started with motorsports.
Susie Wolff: I loved speed, I loved adrenaline, and I loved competition. I was simply a little girl who had a lot of characteristics that fit. And it was in the family. Also, I have a brother who is only fifteen months older than me, and that always spurred me on. I always felt that whatever he could do, I could do. And I had parents who always made me believe that was true, so when we started racing, I didn't think anything of it. But also, in my sport, we wear helmets. Nobody can actually see the athletes. All the talking gets done out on track. And that's where I really tried to show what I was made of.

It definitely got harder as I grew older and wanted to move into single-seaters, because I started to get a lot of media attention as the only girl. At eighteen, I'd finished fifteenth in the world championships, which was a solid result but I wouldn't have been on the podium. And I was called up to receive an award for top female driver in the world. I didn't set out to be a pioneer in a male-dominated sport. I wasn't even aware of how many other women were in the competition, and that was my first realization that I was seen as different.

DS: It's interesting that you started so young. The world wasn't yet telling you what you could or couldn't do. But you still had that realization that things were different for you.
SW: It's very difficult when people ask me what it's like being a woman in a man's world, because I only have my own perspective. I don't know what it's like to be a man in a roomful of men. I know what it's like to have a lot of noise around your gender, something that's irrelevant to my view of success but becomes such a big story. Parts of it were not pleasant. But at the core, for me, I was doing something I loved. I love racing. I wasn't there to prove what a woman could do.

DS: You're now the managing director of F1 Academy, a racing series for women that Formula One launched this year, which develops and prepares young drivers to progress to higher levels of competition. I'd love for you to talk a little bit about what you're trying to achieve there.
SW: Motorsport is very challenging in that you have to make a big financial investment, and not everybody can. So we take the financial burden away. I also don't believe in segregating the sport, because it's one of the few in the world where men compete with women. I don't believe that quotas have a long-term positive effect. What I do believe in is inspiring the next generation so that we can increase participation, which in turn increases the talent pool. Women's participation in the last twenty-five years on track has never gone above five percent. At F1 Academy, we want to show young women that there are opportunities in the sport.

We're not going to watch computerized cars racing against each other. . . . I don't see technology ever replacing the human drama that we love about the sport.

—Susie Wolff

DS: You mentioned that you like to go fast. When I watch a race, everyone on the track seems pretty fast to me. What does that mean from a racer's perspective?

SW: Being fast is dancing on the limit of what the car is capable of to get every last tenth out. And I think, like any sport, the more you do something, the better at it you can become. But the really great racers, they have something more. The Lewis Hamiltons, the Max Verstappens, they have hand-eye coordination, they have the ability to feel a car and push it further than I think most others can push. It's very difficult to put into words.

DS: Speaking of abilities, what do you look for in young drivers?

SW: We're looking for those who show that ability, that tenacity, on track, and who are just as good off track. They have social intelligence; they have a way to build a team around them. And also, even at this level, that they can cope with the pressure. That's what makes all the difference. It's a mental game as much as a physical one.

DS: When you look at the sport today, what do you think are the biggest hurdles? And where do you hope it will be in a decade?

SW: I think it's definitely still a man's world, but the world is changing. I look at it very optimistically. We've been given a great chance now with F1 Academy to change some of the sport's negative characteristics, which means that those with the power to make decisions in the sport have also realized the world has changed.

Diversity is very important. And just talking about diversity isn't enough anymore. If organizations want commercial sponsors on their cars, they've got to have a good diversity program in place, with clear KPIs. We would be crazy in Formula One or within the

world of motorsport if we didn't sit up and take notice that things have changed. And I think enough of us realize this is good for all of us: it's good for the ecosystem, it's good for the business model. It's good in many ways, not just as a feminist crusade.

DS: That's great. I appreciate that message. Before we go, could you talk for a moment about what driving a race car feels like?
SW: It's very lonely in a racing car. As much as there's huge excitement outside the car, inside you are a thousand percent focused. Of course, there'll be the nerves deep inside, but you're fully focused on the start lights and your starting procedure. So you're never having this flustered nervousness that maybe spectators do watching. What I loved about driving was how that focus blanked out any other thoughts. It comes down to the minute details—how you release the clutch, how much throttle you have—and that comes down to one percent too much throttle or a degree of releasing the clutch. And that's obviously where coping with pressure becomes a huge advantage, because the pressure itself is huge, and the line between success and failure is very thin. Make one small error on a track like Monaco and you're in the bar, you're the biggest loser, and it's hero to zero.

DS: How do you think this focus on the driver might change with all the technology that is coming into racing?
SW: I think a big part of Formula One's appeal is that it's at the forefront of emerging technology. When they're doing preseason testing, they have up to eight hundred sensors on a car, creating data. But in the end, data doesn't make decisions. As much as technology is driving the sport forward in many, many ways, there's still that human element. We're not going to watch computerized cars racing against each other. We love heroes. We love the gladiators out there trying to win and to beat each other, and there's accidents and there's drama. That's also a big part of Formula One. Of course I see electrification coming more into Formula One in time, but I don't see technology ever replacing the human drama that we love about the sport.

Susie Wolff MBE is a Scottish former professional racing driver and current managing director of F1 Academy.

David Sze is a partner at the venture capital firm Greylock Partners. A motorsport enthusiast, he is on the Board of Advisors for McLaren Racing.

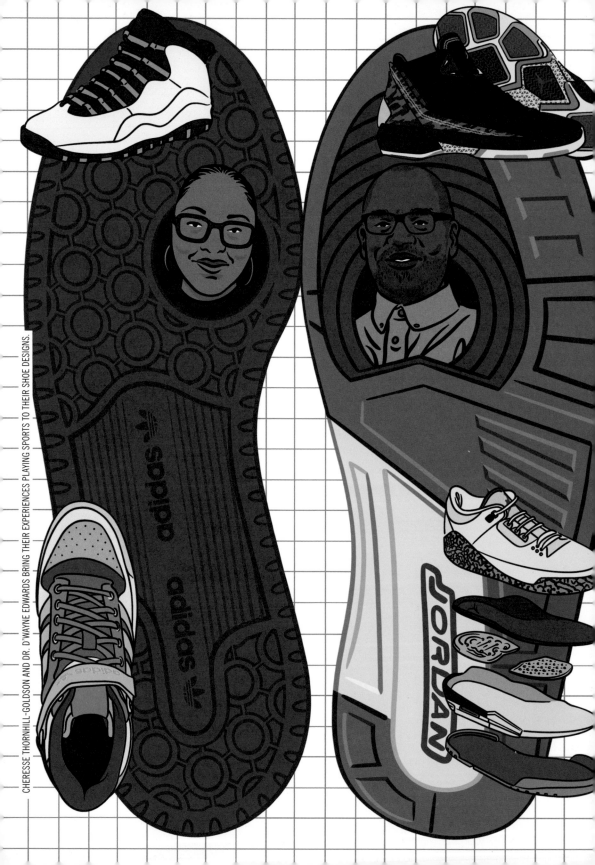

IS IT THE PERSON THAT MAKES THE SHOE OR THE SHOE THAT MAKES THE PERSON?

Cheresse Thornhill-Goldson & Dr. D'Wayne Edwards

Cheresse Thornhill-Goldson: For both of us, basketball has been an important part of our foundational life experiences. I would love to hear how it has influenced your design process.

Dr. D'Wayne Edwards: I grew up playing basketball, and it has given me a different perspective as a designer. The beauty of a performance product is either it works or it doesn't. And if you're able to get that information firsthand by being a user of the product, it'll make you intuitively better at creating for that sport.

CT-G: I grew up playing basketball too, and I totally agree with you. I was a woman mainly playing against guys. I think that helped me in terms of developing a competitive spirit that I bring to everything I do, and also made me realize that whether you're getting better at designing a shoe or improving your free throws, it's all about practice.

DE: With practice, you come to fundamentally understand what you're supposed to do, and then you can do it your own way versus trying to do it the way you saw your favorite player do it. Design is the same. You have to have that same level of obsessive competitiveness to be successful at it, and find what works for you.

I think every kid needs to play sports. It's hard to learn teamwork and collaboration if you haven't experienced that anywhere else. I remember once at Nike when the Jordan team wasn't getting along. And Howard White [vice president of sports marketing for Jordan Brand] called MJ and was like, "Black Cat, these boys can't get along. Every time I come around them, they're always arguing." And MJ said, "Look, I didn't start winning until I realized there were four other people on the floor. I won every individual award you could win in the game of basketball. But I didn't win the team award until seven or eight years after I got into the league, when I realized there were four other people on the floor that could help me win. You guys need to get y'all shit together." And then he hung up the phone.

CT-G: Was that a turning point?
DE: It really was, because we all played sports, so we understood the analogy and saw it was true. We couldn't win by ourselves. Sports made us who we were competitively, and also made us understand how to work as professionals.

CT-G: Was there a sneaker that changed it all for you, that made you start paying attention to shoes as something more than just things that you put on your feet?
DE: It was the Air Jordan 3, because it broke a lot of the rules. Back in the late '80s, early '90s, all the basketball shoes were high-tops. And the 3 was not, but it wasn't a low top either. It was a weird height that made you think, should I wear that? But then you had Mike doing it and it's like, "Oh, well, shit, if he can do it, I guess it's good for me too." And beyond that, it didn't look like a basketball shoe. It almost looked too pretty to play in. There was no big Nike Swoosh, and the textures and color blocking were different. It was the first to really start to bridge the gap between basketball and lifestyle—getting even more jean friendly, so to speak. There were so many firsts with that one. First championship Michael won in Inglewood, I snuck in the Forum and watched the game. So I was able to see it in person, in action.

CT-G: That's very cool. For you, it was the Jordan 3; for me, it was the Jordan 10. I was in the fifth grade in PE class and this kid showed up in the Jordan 10s—the original colorway, the all-white with the black-and-gray tongue. That whole line was something you just had never seen before—you know this because you were director of Jordan for a while. They really got me paying attention to sneakers.

I always have this debate with people, but also in my own mind: Is it the person that makes the shoe or the shoe that makes the person? I don't know.

DE: In the case of MJ, it's both, and I say that because after he stopped playing in them, the shoes have not performed as well sales-wise. So there's an emotional correlation there that I think has to be considered.

CT-G: Air Jordans are like a visual representation of excellence, the power of human potential.

DE: Now they have cheaper products, but the line has never been in an accessible zone where it feels everyday. I was just rewatching *The 1619 Project*, and Nikole Hannah-Jones is interviewing this white dude, and he says he's wearing Costco Jordans, and she has on Air Jordans. And the whole documentary is about us and slavery, and I thought about how no matter how many signature athletes there have been before and after him, MJ's really the only Black one that's ever had his own brand. Every other signature athlete, the parent company's logo is on that shoe, except for his. He is the only Black man that has his own sneaker company, so to speak.

CT-G: It's so interesting, what the Jordan line means to sneaker culture and also to us as a community.

DE: Jordan is such an interesting case study. What made it successful, the product or the person? And why hasn't that success ever been repeated? There were just so many things that collided at the same time.

Sports made us who we were competitively, and also made us understand how to work as professionals.

—Dr. D'Wayne Edwards

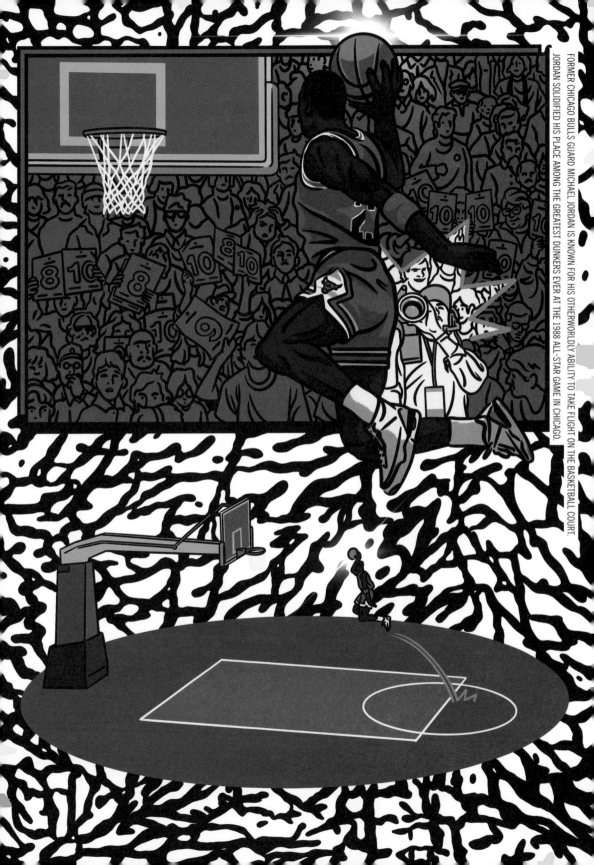

FORMER CHICAGO BULLS GUARD MICHAEL JORDAN IS KNOWN FOR HIS OTHERWORLDLY ABILITY TO TAKE FLIGHT ON THE BASKETBALL COURT. JORDAN SOLIDIFIED HIS PLACE AMONG THE GREATEST DUNKERS EVER AT THE 1988 ALL-STAR GAME IN CHICAGO.

CT-G: It was timing, and a lot of firsts. And if you are the prototype, you become the standard.

I would argue that you're doing the same thing in the design education space. You started Pensole years ago, and you were the first to challenge design education by making it accessible—even free, initially. And also starting design education in a corporation with Future Sole and with the Wings program, and really bringing awareness to corporations that they can have a hand in developing the next generation of talent.

DE: It's about respecting the place before you start walking. I just applied my design principles that I had learned over time in a new way.

CT-G: I think your sports background was important too. Collaboration and teamwork are some of the biggest things I learned from you. I would like to see us as a community take our approach to sports and the game and apply it to educational solutions and building communities.

DE: To me, that is exactly where we are society-wise. I think on some levels, sports allow Black folks access to opportunities that many of us probably wouldn't have otherwise. And imagine if you remove Black people from sports? It would be hella boring. There would be no Nike, there would be no Adidas.

CT-G: Very true. And sports also influence fashion—back to the Jordan brand and what that has become.

DE: If you removed Black people from design and fashion, from sports, and from entertainment, if you removed us from those three things that we have excelled the most at, America would not be the same, the world would not be the same. So to me, that's just proof of concept to give those an opportunity to show you different.

Cheresse Thornhill-Goldson is a sneaker designer and the design director at Adidas School for Experiential Education in Design (S.E.E.D.), where she works to build a community for young designers, specifically women of color.

Dr. D'Wayne Edwards is the founder of Pensole Lewis College, the first footwear design academy in the US and the country's first design-focused historically Black college. His more than three decades in the field include a ten-year stint as design director for Nike's Jordan Brand.

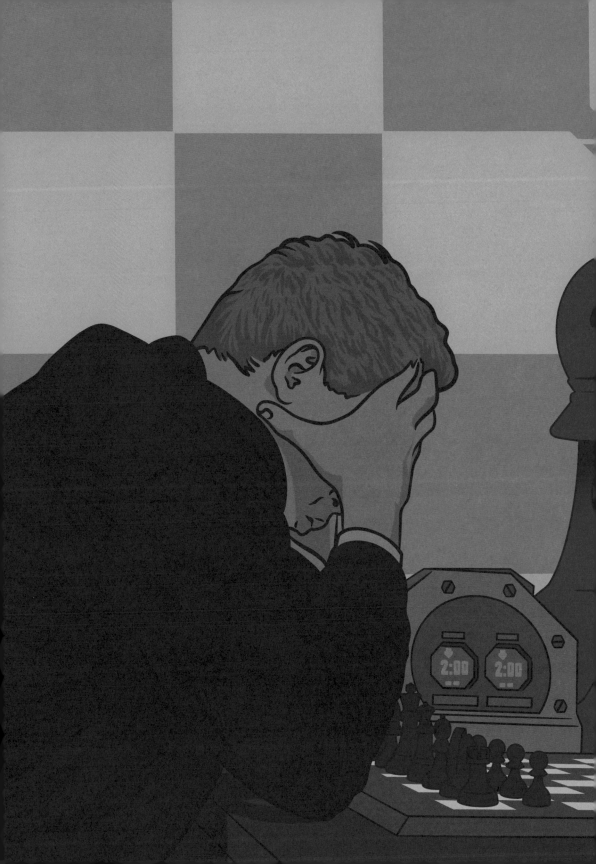

IN MAY 1997, GARRY KASPAROV COMPETED AGAINST IBM'S CHESS COMPUTER DEEP BLUE. KASPAROV WON THE FIRST GAME; THE MACHINE WON THE NEXT. AFTER THREE ROUNDS THAT ENDED IN A DRAW, DEEP BLUE WON THE FINAL GAME AND THUS THE MATCH, BECOMING THE FIRST MACHINE TO TRIUMPH OVER A WORLD CHAMPION.

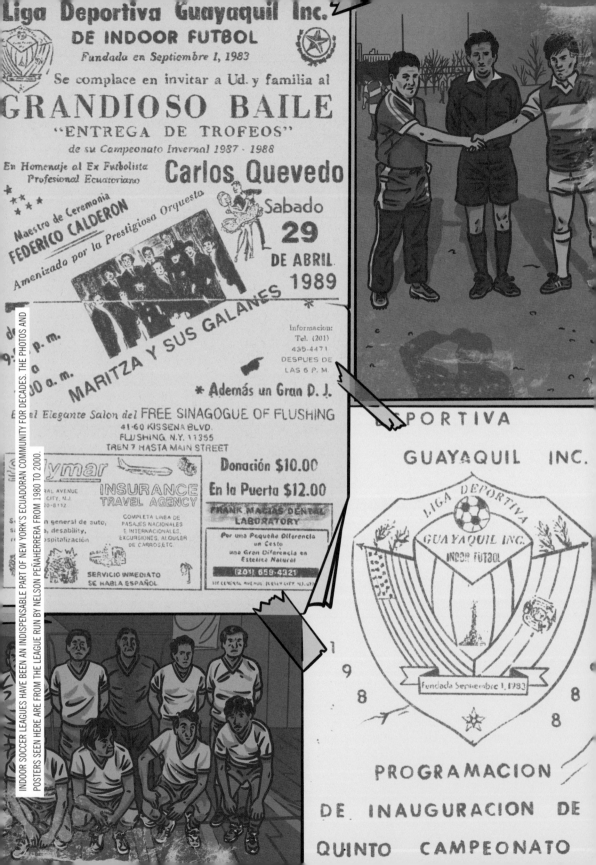

Liga Deportiva Guayaquil Inc.
DE INDOOR FUTBOL
Fundada en Septiembre 1, 1983

Se complace en invitar a Ud. y familia al

GRANDIOSO BAILE
"ENTREGA DE TROFEOS"
de su Campeonato Invernal 1987 - 1988

En Homenaje al Ex Futbolista
Profesional Ecuatoriano

Carlos Quevedo

Maestro de Ceremonia
FEDERICO CALDERON

Amenizado por la Prestigiosa Orquesta

MARITZA Y SUS GALANES

Sabado
29
DE ABRIL
1989

Información:
Tel. (201)
435-4471
DESPUES DE
LAS 6 P. M.

9:00 p.m.
a
3:00 a.m.

*Además un Gran D. J.

En el Elegante Salon del FREE SINAGOGUE OF FLUSHING
41-60 KISSENA BLVD.
FLUSHING, N.Y. 11355
TREN 7 HASTA MAIN STREET

Donación $10.00
En la Puerta $12.00

lymar INSURANCE TRAVEL AGENCY
RAL AVENUE
CITY, N.J.
20-8112

en general de auto,
a, desability,
hospitalización

COMPLETA LINEA DE
PASAJES NACIONALES
E INTERNACIONALES,
EXCURSIONES, ALQUILER
DE CARROS,ETC.

SERVICIO INMEDIATO
SE HABLA ESPAÑOL

FRANK MACIAS DENTAL LABORATORY
Por una Pequeña Diferencia
un Costo
una Gran Diferencia en
Estética Natural
(201) 659-4321

DEPORTIVA

GUAYAQUIL INC.

LIGA DEPORTIVA
GUAYAQUIL INC.
INDOR FUTBOL

Fundada Septiembre 1, 1983

1
9
8
8
8

PROGRAMACION

DE INAUGURACION DE

QUINTO CAMPEONATO

REMAKING THE RULES

Ronny Quevedo & Nelson Peñaherrera

Excerpted from a conversation conducted in Spanish

Ronny Quevedo: In my work, I think about spaces that I've been to or spaces that are being reimagined. They vary, but I've concentrated on playing fields—thinking about indoor soccer leagues in particular, as they relate to New York and the world at large. I'm interested in mapping these spaces of play.

These fields, and their various uses, run parallel to the notion of movement from one place to another. So, as I explore them in my work, I'm thinking about home and about foreign spaces—sites that are in constant negotiation. It's about how we acclimate and how we operate and navigate spaces that are new to us. And about inventiveness and reimagination.

Soccer has been a big part of our family history. My father, Carlos Quevedo, was a professional soccer player in Ecuador, and when we moved to New York he continued playing in indoor and outdoor soccer leagues. Later, he established a ten-year career as an amateur referee, including for the indoor soccer league that you ran for twenty years in New York City. Could you tell me about starting that league?

Nelson Peñaherrera: The league started in 1980 and ended in 2000. Its purpose was to give people something to do to keep them from getting involved in improper things. But playing indoor soccer (this is what we call any soccer game involving a small ball, played on a small field or court, either outside or inside), that goes way back. We used to go to a park in Brooklyn and play on Saturday afternoons. We were just having a kick about, nothing serious, and then it hit me. I said, "Why don't we start a league?" We wanted to do something.

RQ: More than just playing.

NP: Yes, more than just playing, because there was no structure. As more people learned about it, more teams joined. Once the league was formed, things started to change. First, we set up a committee. Then someone said, "Why don't we have an interleague?" So we started playing in the interleague and even aimed to play, as they say, for the bigger leagues at the fields they had in Queens.

RQ: After some time, you must have realized how valuable the league was. I mean, people were eager to watch it when winter came. I remember, for example, that the newspapers *Noticias del mundo* and *El diario* always covered the league. I felt it had cultural value. It meant something to the community.

NP: Yes, within the sports scene, it had cultural value for sure. We would organize a tournament dedicated to a former professional player from a specific era or country. The other leagues didn't really do that. They just wanted people to come, play, and pay the entrance and team registration fees; that was it.

RQ: For those who don't know, what are the main differences between indoor soccer and outdoor soccer?

NP: Indoor soccer fields are much smaller than outdoor fields, so play is faster. And there are about half the number of players—just five to seven, max. Because there weren't any indoor soccer fields when we started the league, we used the dimensions of school basketball courts.

RQ: Did that rule exist already?

NP: No, we made that up. I developed most of the rules based on FIFA's regulations. The other leagues would just copy them or make up their own rules however they pleased. [*laughs*]

RQ: When my father was working with you as a referee, how did you two manage to keep things in order, like making sure people followed the league rules? I remember him researching and staying up to date with rules, and even having a FIFA rule book because he always wanted to be prepared.

NP: I didn't have any issues because I made it clear, "I'm the boss here; there's no one else. These are the rules for the players, the rules for the referees, and the rules for the crowd." In other leagues, they'd throw punches. I never had any trouble. Everyone respected each other.

RQ: Did you and my dad discuss the rules and how to improve them?

NP: Exactly. We would have brief meetings where we would clarify any rule changes. Most of the time, they would basically stay the same. My role was to make sure the referees followed them. If they didn't follow the rules, I had to replace the referees.

I like to bring into play multiple sets of over-lapping, coinciding, and even conflicting rules. Manipulating and bending them can be a powerful way of finding new paradigms.

—Ronny Quevedo

RQ: You always had an announcer commenting on the games, whether inside the stadium or the gym. I've never seen any other league do that.

NP: Yes, I would give the announcer up to $100 per game. I also hired someone to sit at the control table and keep track of match statistics: the winners, the losers, the ones who got expelled—all those things. I'd go back home, check everything, and organize it. It was important to keep records to avoid any accusations of me manipulating the outcome of the matches for profit. That was happening in many other leagues.

RQ: I can imagine. You also gave out trophies and prizes, right?

NP: Only trophies. Plaques, trophies, award certificates—I gave them all those things, but no cash because it's always messy. I've known leagues where people would even threaten to stab each other over money.

RQ: After your twenty years with the league, what do you think is the importance of having a system of rules within the sport or for oneself?

NP: A system of rules is very important. The bad thing is that today they have replaced the referee's authority with the VAR [video assistant referee] system, which makes mistakes all the time.

RQ: I've always been interested in the logic of rules and their intention to construct a neutral space—creating a collective vision of fairness. I think my dad felt similarly that in soccer, rules provide a framework for a sense of certainty and honor. Yet sports can also be a place of passion, euphoria, fanaticism, and failure. Somehow, reveling within the bounds of rules, there's a great call for surpassing them. This kind of reimagining is a big part of the reason I'm interested in rules in my work. I like to bring into play multiple sets of overlapping, coinciding, and even conflicting rules. Manipulating and bending them can be a powerful way of finding new paradigms—not just for navigating a broken system but for creating new models of engagement.

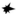

Ronny Quevedo is an Ecuador-born, New York–based artist whose work explores the layered histories of his heritage, his parents' lives, and the collective experience of sports. He is Nelson Peñaherrera's nephew.

Nelson Peñaherrera founded and ran the Liga Deportiva Guayaquil de Indoor Futbol in New York (1980–2000). He is Ronny Quevedo's uncle.

I've always been interested in the logic of rules and their intention to construct a neutral space.... I think my dad felt similarly that in soccer, rules provide a framework for a sense of certainty and honor.

—Ronny Quevedo

AT THE 1986 FIFA WORLD CUP IN MEXICO CITY, ARGENTINA'S DIEGO MARADONA USED HIS HAND TO SCORE A GOAL AGAINST ENGLAND. BECAUSE THE REFEREE'S SIGHT LINE WAS BLOCKED—THIS WAS BEFORE VIDEO REPLAY—THE GOAL COUNTED; ARGENTINA LATER WON THE TOURNAMENT. WHEN ASKED IF THE GOAL WAS ILLEGAL, MARADONA CLAIMED HE SCORED IT "A LITTLE WITH THE HAND OF GOD."

ON SEPTEMBER 2, 2013, AT AGE SIXTY-FOUR, DIANA NYAD COMPLETED THE 110-MILE SWIM FROM HAVANA, CUBA, TO KEY WEST, FLORIDA, THROUGH JELLYFISH- AND SHARK-INFESTED WATERS, IN APPROXIMATELY 53 HOURS.

INFINITE HORIZONS

Catherine Opie & Diana Nyad

Catherine Opie: We share a love of water. And we share a love of community and philosophy and digging deeper and learning. I do that through art. And you do that through sports and activism and also being a motivational speaker. So I thought we could explore some of this common ground. And I think that we should start first with the idea of horizon lines.

One of the things I've been thinking about is how different our horizon lines are. As you know, swimming is a real passion for me. I think about the horizon as a place of meditation and, in my photographs, as a place to bring the viewer. And I want you to talk a little bit about your relationship with swimming and the idea of horizons.

Diana Nyad: I was born in New York City, but by the age of seven I was in South Florida, and looking out over the ocean at that horizon, it looks like forever. I feel like not being around the ocean limits your vision. Because for me that ocean horizon, more than any other, represents what is possible. We see it and say, "I can do anything. I'm thinking bigger. I'm thinking in a grand way."

In the cottage where Bonnie and I lived in 2013, the last year of my training for the successful crossing from Cuba to Florida, there was this black-and-white photograph that was framed in a real door. It showed this figure looking out across the sea at the

horizon. And below it was etched a Pablo Neruda quote that says, "I know you won't believe me, but it sings. Salt sings. Dust of the sea. In you, the tongue receives a kiss from ocean night. In it, we taste infinitude." That word, *infinitude*, is what the horizon means to me. It means there is no barrier to what you can do.

CO: That's a really beautiful sentiment. I think that that's what I'm trying to do as well in relationship to the horizon line in my work.
DN: I also think about horizons in terms of the possibilities for all human beings on earth to live the biggest, best lives they possibly can. Everyone under the blue sky deserves water to drink and food to eat and to be loved. And if we're lucky to pursue some of our creative or passionate innards, we deserve that too. That's my democracy.

CO: And I would say that my democracy is somewhat the same. But it's also different because you aspire to great feats most people would deem impossible. And I don't have that. My drive is to make work that conveys a relationship to representation and what it means to be visible and what it means to be a dyke, which I call myself—a dyke and a lesbian. And I use words like that in relation-ship to my sexuality, because of the community that I came out of.
 I think that there are different things at stake for an athlete. I think both of us have goals, and that we go forward and pursue them. But as an artist I give back in a very quiet way, where people just stand in front of my photographs and they have to figure out what I'm thinking. Sports also has a relationship to representation and needs an audience in a certain way, but artists have a different rap than athletes, right?
DN: That is so true.

CO: You guys get to be heroes. Artists are often thought of as being self-absorbed. There's a certain kind of idea of genius attached to us, which I don't believe in. There're all these ideas, also, that artists are flaky. Yet museums and the art world are a part of how we express culture.
DN: I agree, but I'd add that in sports sometimes it's just about sheer joy. There are a few athletes, the Muhammad Alis of the world, the Billie Jean Kings, and they are pinnacles of achievement and even social justice. But when you go down to the local pool or the local tennis club or the beach, kids are doing athletic endeavors that are more about play and about the freedom of the body. And so we athletes can feel that, too, even if we're in pursuit of something—it's not all about breaking records.
 In marathon swimming, there are so many hours of training, and there's such a grueling aspect to it that you tend to only talk about that. But out there in the ocean, fifty miles from shore, there is joy to it, there's awe to being an athlete. So neither artists nor athletes are as clichéd as one would think.

That ocean horizon . . .
represents what is possible.
We see it and say, "I can do
anything. I'm thinking bigger."
—Diana Nyad

My drive is to make work that conveys a relationship to representation and what it means to be visible and what it means to be a dyke.

—Catherine Opie

CO: You mentioned the hours that go into it, to get to that swim. Same with an artist. People often forget about that by the time they're in a museum—the hours and hours it took to get to the work they are seeing. Both of our fields involve grueling aloneness. Obviously, when I make portraits, I'm not alone. But when I'm out for hours on the snow and the icehouses with an 8 × 10 camera, watching the light slowly change as a blizzard comes in, that has its own kind of endurance to it. It's not the endurance of an athlete, but I think there's a similar mindset.

DN: Just like when you go watch Venus Williams play tennis. She has natural talent, but you can see that her skill didn't just develop overnight. And for me, it's not just a matter of talent for swimming, but about the unrelenting focus I put in over a long, long period of time. And so I assume that with most artists, when you see their work you'd say, "This represents a lifetime of dedication."

Unfortunately with sports, your career ends a bit earlier than an artist's does, as a general rule. So I started tennis when I was sixty-eight. Come on, how good am I going to be? But I do have some potential. And whatever that potential is, I'm seeking it. The athlete in me is still seeking. I want to feel that there was nothing more I could do, every single day, until the last breath comes.

CO: Yeah, that's beautiful. That's, I think, what I strive for, too, but there's still that drive to create something that is going to make people think differently, that is going to allow another door to open.

DN: And a counterpoint is that you'll hear younger athletes, ten, eleven, twelve, and they're pretty good. And they're not saying, "I want to hit the most beautiful backhand that's ever been released." They want the fame of what that would bring.

CO: And they should be saying, "I want to become an expert in my field."

DN: That's it.

CO: The problem is, expertise is often conflated with fame. But expertise should be about that individual kind of passion.

DN: The passion for the craft. And if anybody gets to know you for it, great. You're lucky. If they don't, you'll still have that passion and discipline.

Catherine Opie is a photographer and educator who investigates the ways in which photographs both document and give voice to social phenomena in America today.

Diana Nyad is the only person in history to swim between Cuba and Florida without a shark cage. Her multiple attempts to achieve this goal with the support of coach Bonnie Stoll are chronicled in the hit Netflix movie *NYAD* (2023). She has been a sports broadcaster, journalist, and writer for over thirty years.

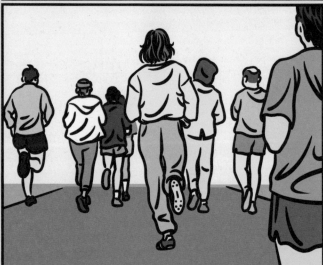

IN 1967, KATHRINE SWITZER BECAME THE FIRST WOMAN REGISTERED TO RUN THE BOSTON MARATHON. DURING THE COMPETITION SHE HAD TO FEND OFF ATTEMPTS BY RACE DIRECTOR JOCK SEMPLE TO PHYSICALLY REMOVE HER FROM THE COURSE. TODAY MORE THAN 40% OF RUNNERS IN THE MARATHON ARE WOMEN.

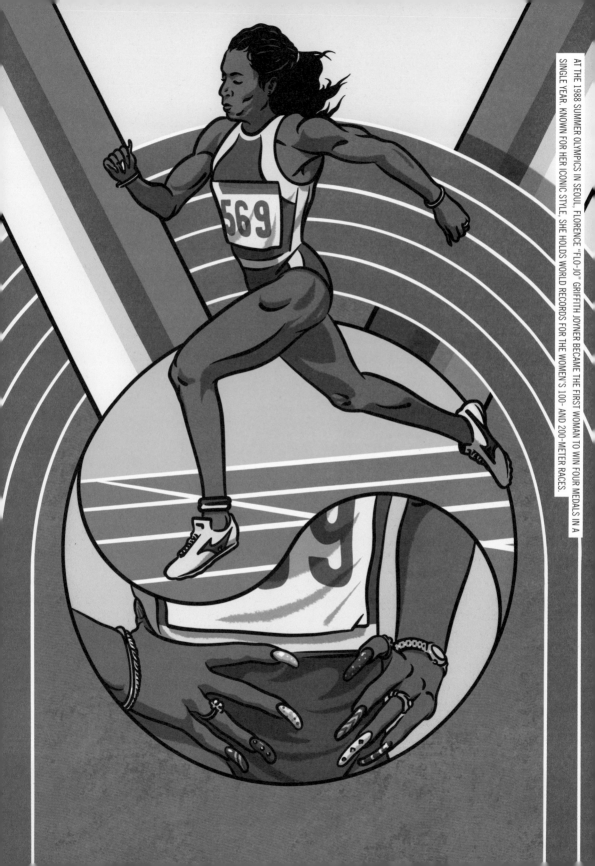

AT THE 1988 SUMMER OLYMPICS IN SEOUL, FLORENCE "FLO-JO" GRIFFITH JOYNER BECAME THE FIRST WOMAN TO WIN FOUR MEDALS IN A SINGLE YEAR. KNOWN FOR HER ICONIC STYLE, SHE HOLDS WORLD RECORDS FOR THE WOMEN'S 100- AND 200-METER RACES.

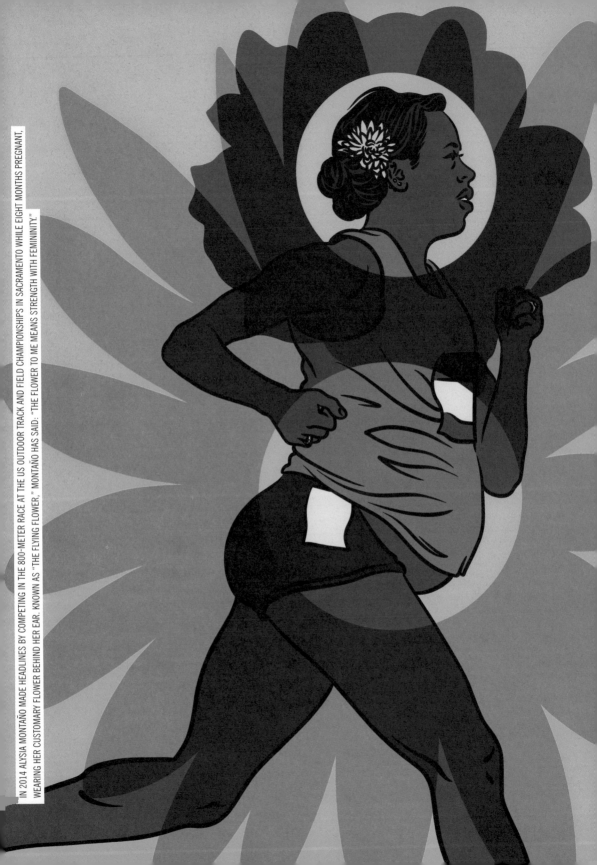

IN 2014 ALYSIA MONTAÑO MADE HEADLINES BY COMPETING IN THE 800-METER RACE AT THE US OUTDOOR TRACK AND FIELD CHAMPIONSHIPS IN SACRAMENTO WHILE EIGHT MONTHS PREGNANT, WEARING HER CUSTOMARY FLOWER BEHIND HER EAR. KNOWN AS "THE FLYING FLOWER," MONTAÑO HAS SAID: "THE FLOWER TO ME MEANS STRENGTH WITH FEMININITY."

I'M A WOMAN AND I'M ASKING FOR EQUITY

Alysia Montaño with Jane Gottesman & Evelyn C. White

Evelyn C. White: Alysia, you ignited a national conversation about women athletes, equity, and motherhood when, in 2014, you successfully completed an 800-meter race while eight months pregnant. The photos of that event are astounding—so few of us had seen a pregnant athlete competing before. For the historical record, what are your accomplishments in track?

Alysia Montaño: I was the California State Meet champion in the 800 meters in high school. I earned a full ride to the University of California, Berkeley, where I became a two-time NCAA champion in the 800 meters. There, as a collegiate, I also won my first NCAA national title—as a junior against a bunch of pro athletes—which earned me a professional career in running. I became the seven-time USA national champion over the 600-meter distance and the 800-meter distance. I am a US Olympian. I also have won two world championship bronze medals, a gold world championship medal, and a silver Pan American medal. I've been a two-time American record holder.

Jane Gottesman: What records did you hold?

AM: I held the American record in the indoor 600 meters, and in the 4 × 800-meter relay. I'm also the author of a book, *Feel-Good Fitness*, and I have three awesome children—Linnea, Aster, and Lennox.

ECW: As a youth, you played soccer, baseball, basketball, and street hockey. How did track win out?

AM: I think track kind of chose me. I happened to be an overall athlete. A lot of folks who end up having a professional running career consider themselves runners alone. I consider myself an athlete of all the sports I played. Running is in every sport and I happened to be the fastest on the team in every single sport that I played. I love moving my body and I love a challenge.

Fear of the female is what I started to recognize, and this has been a pattern throughout my entire life. What if we empower women to know more about their bodies and to have agency over them? —Alysia Montaño

JG: For world-class athletes like yourself, every muscle in the body is studied to understand how the whole system works and how to make it even more optimal. The uterus as a muscle hasn't been studied with regard to how it can be optimized for an elite athlete. What have you learned as an athlete who has really worked with that muscle?

AM: A lot of the performance metrics are based on our data default: the male body. So when I was considering motherhood, I started thinking about how I would return, postpartum, in as top form as possible. But there is little research. We talk a lot about diaphragmatic breathing, which happens to also pertain to the pelvic floor and the uterine wall, but those words aren't mentioned. You want to know why? Because every word pertaining to the female body is a dirty word.

And most of the coaches are men. Fear of the female is what I started to recognize, and this has been a pattern throughout my entire life. What if we empower women to know more about their bodies and to have agency over them?

ECW: They start looking like you and become winners.

AM: That's exactly what can happen if we have an army of women who know the power of their bodies. The opposition is coming from the patriarchy. It's this fear that society is going to lose something. Instead, there is so much to gain. And I started thinking about what I can do to empower the space for female athletes, which has not been given the platform it deserves.

JG: With the space being?

AM: Athletes and motherhood. Or not even athletes and motherhood, let's just call it female athlete empowerment. You're seeing the rise of it, right? You're seeing all of these women athletes right now saying, "Your talking time's up. Why am I of less value than my male counterparts? And we win more."

ECW: On that note, could you talk about your *New York Times* op-ed and how it prompted Nike to change its sponsorship policy, so that women athletes aren't penalized financially for becoming pregnant?

AM: When we become professional athletes, we're looking at contracts that have been standard for men. There isn't anything that could be considered relevant for the female body—pregnancy, maternity, postpartum. So I signed a contract with Nike that was standard and that allowed me to perform and compete across the entire world. It had clauses in it that stipulated if I couldn't get back to fitness after an injury for a six-month period of time, then I could be cut. I could be reduced for all of these reasons. And that seemed to be fine with a lot of people.

The contracts they were paying men were five times the amount for women. I had a male counterpart whose contract and bonuses were five times greater than any of mine. As we were rolling into negotiations and I mentioned pregnancy, equity in contracts and pay, they literally said to me, "We'll just stop your contract and stop paying you if you were to become pregnant." They also told me that they had "a look" and that I didn't fit the market.

ECW: Because you're Black?
AM: And I'm a woman and I'm asking for equity. I had shared with a *New York Times* reporter . . . the consequences—which is wild—of being a female athlete. That just kind of set it off that this ends with me. I just pushed Nike. Because they are the leaders in sports marketing. You should be able to negotiate a contract and not have to tell anybody what you want to do with your vagina or your family, or whatever. I eventually went on the record and the op-ed came out on Mother's Day in 2019.

JG: Did you violate some kind of confidentiality clause to speak openly?
AM: Yes, I did. I was terrified. But I had nothing to lose at that point.

ECW: Few children have images of themselves inside their mothers. Because you ran while eight months pregnant with your firstborn, Linnea, there is footage in addition to the photos. How has that impacted her and your other children?
AM: The kids think it's so cool. Linnea just told me that she wanted to run track and said, "Mom, you are my hero." I told her, "Be your own hero, but I feel so honored." She knows everything about me running with her inside of me and her journey into the work that I do.

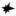

Alysia Montaño is a middle-distance runner and a six-time champion in the 800 meters at the USA Outdoor Track and Field Championships.

Jane Gottesman is the founder of Working Assumptions, an organization that explores systems of care through photography of family. Her reporting for the *San Francisco Chronicle*'s Sporting Green resulted in the 2001 exhibition and book *Game Face: What Does a Female Athlete Look Like?*

Evelyn C. White is a journalist and author whose books include the biography *Alice Walker: A Life* (W. W. Norton, 2004). A former reporter for the *San Francisco Chronicle*, she now lives and writes in Halifax, Nova Scotia.

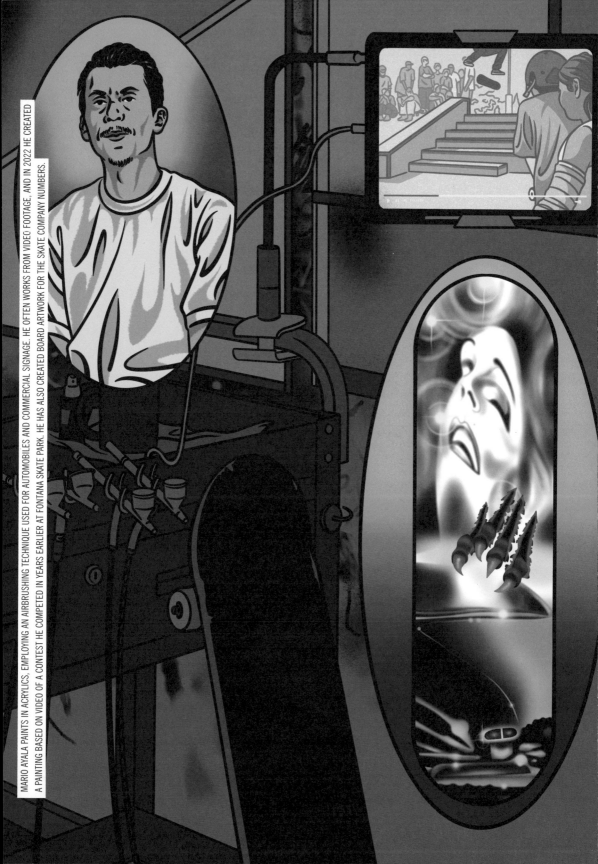

MARIO AYALA PAINTS IN ACRYLICS, EMPLOYING AN AIRBRUSHING TECHNIQUE USED FOR AUTOMOBILES AND COMMERCIAL SIGNAGE. HE OFTEN WORKS FROM VIDEO FOOTAGE, AND IN 2022 HE CREATED A PAINTING BASED ON VIDEO OF A CONTEST HE COMPETED IN YEARS EARLIER AT FONTANA SKATE PARK. HE HAS ALSO CREATED BOARD ARTWORK FOR THE SKATE COMPANY NUMBERS.

GRIP TAPE

Mario Ayala & Leo Fitzpatrick

Leo Fitzpatrick: You said recently that you don't think you'd be making art if it wasn't for skateboarding.

Mario Ayala: Yeah, my father used to take me to the skate park on the weekends, and we'd always go to this small skate shop nearby and he'd get me a few stickers. When we returned home I'd instantly try to draw them. It was instinctual; I suppose it was the way I learned how to draw. Skateboarding still offers a special kind of release that I can't achieve with anything else. It's painful, it's ephemeral, it's wonderful.

LF: You made a painting called *Fontana Skate Contest*. When was the last time you watched the Fontana skate contest footage it's based on?

MA: I just watched it right now.

LF: Do you remember how that day unfolded?

MA: Yeah, definitely. These dudes at Pharmacy Boardshop asked if I wanted to be in a contest. They wanted to do it on this kind of four-block rail, but I was like, "I want to skate this bank to ledge." I wasn't even trying to skate stairs or rails. And for whatever reason they thought I was pointing at that hubba, the concrete ledge along an even bigger set of stairs, and they're like, "Fuck yeah, Mario wants to skate the hubba!" And then all of a sudden that was the contest.

LF: Who are some of the other guys in the video? Were they locals or just your standard park instigators, like the guy at the beginning of the video?

MA: His name is Buffkin. He was a character at the park. He skated but also just hung out and was kind of always up to no good. In terms of skating, there was a good friend of mine, Brian Sawyer, and Steve Brainard, a guy they called Bill Gates because he had glasses—he was the one who was really killing it, doing frontside flips, and he won the contest. Jake Mathis, who filmed that, was a friend of mine. He would take us around skating spots, filming, but he also had an interest in art in general, so we'd always end up going to see art shows while we were out skating.

LF: What was it like growing up skating in and around Fontana?

MA: I moved to Fontana in 1999, I believe, and I started skating the next year, when I was six or seven. If you didn't have a car, skateboarding in Fontana was very difficult to do. Me and my friends basically just skated everywhere, and skating everywhere in the Inland Empire takes a really long time because there's still a lot of undeveloped roads. So the spots are basically high schools, some shopping centers, and ditches. A lot of ditch spots.

Those ditch spots ended up being the places you could skate, you could do graffiti, you could smoke weed. It felt like there was a bit more freedom and less surveillance. Unlike in a city, you kind of stand out in the Inland Empire if you're not into Abercrombie & Fitch and going to the movies.

LF: Were you thinking of a life outside Fontana at this time?

MA: I think that video was shot around the time I was finishing high school. I remember being pretty against the grain of my father, who had grown up when there was a bigger emphasis on being this kind of macho male figure. I was wearing tight pants; I was growing my hair out long; I was super into glam rock. I think a lot of it had to do with watching skate videos. It wasn't too long after the Fontana skate contest that I was starting to paint and be more interested in art, and that was also a little bizarre and maybe out of pocket for my parents.

LF: Do you ever miss those days of experimentation and finding yourself, or are you happy that's over with?

MA: I feel like we're always students in this world, but especially then I felt so naive. I was trying to digest all of these exciting things that, for me, felt ultra new because I didn't really have any frame of reference for them. Skateboarding, types of music, and also visual art. I think about how carefree those days were, and maybe in some ways kind of dangerous too. The only real daily goal was to go outside and hang out with my friends, and skateboarding ended up being the thing we did together. I have definitely missed those moments often. When I find myself skating now, even if it's for an hour or two with my friends, it brings me back to that era, and I feel like that's something that skateboarding can constantly do. It still feels as freeing and innocent as it once did.

People who are skateboarders or graffiti writers or sign painters, tattooers. There's a hybridity to these artists who, for whatever reason, found one another. A similar consciousness.
—Mario Ayala

LF: Your friends play a large part in your practice. Can you talk a bit about your community?

MA: I feel like I've always been more attracted to kindhearted people rather than to people who are too cool or egotistical or competitive. I've been really lucky to find people who share the same morals and interests. That's even beyond friends of mine like Rafa Esparza and Lupe Rosales—people who are skateboarders or graffiti writers or sign painters, tattooers. There's a hybridity to these artists who, for whatever reason, found one another. A similar consciousness. I feel lucky that most of my friends who are within this larger web are all very kind to one another and want to share and communicate with one another, be in the same space, share space. It feels like it all happened very naturally. I realize that it's rare but it's also kind of normal and beautiful, because I've always wanted a larger web of friends and community that can grow together—that's pretty integral to my practice. My friends are an extension of my family.

Mario Ayala is a painter who engages traditions and techniques with strong visual ties to his native Southern California, such as muralism, tattooing, and the airbrushing used for automobile painting and commercial signage. He has been skateboarding since he was in elementary school.

Leo Fitzpatrick is an actor and former co-director of the Marlborough Chelsea gallery. He was discovered at age fourteen by director Larry Clark while skateboarding at Washington Square Park in New York.

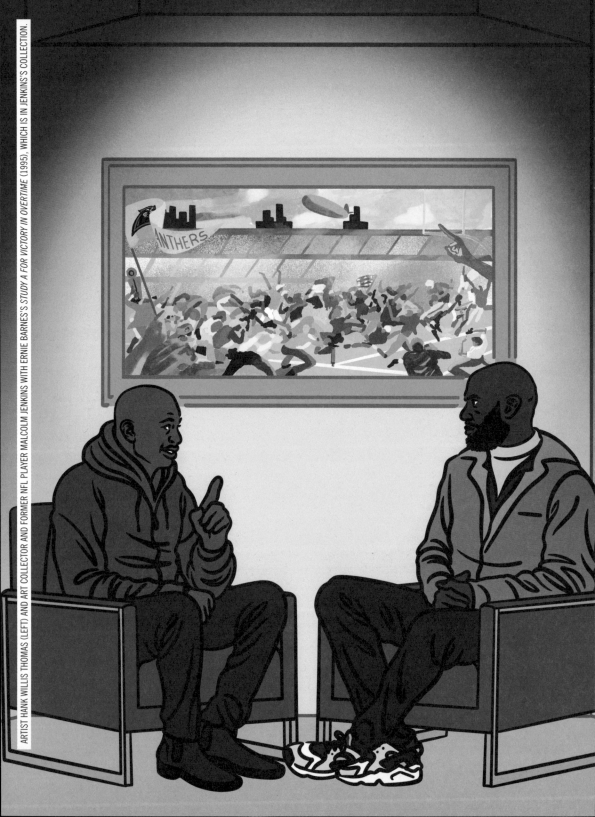

ART CAN GET YOU TO A DIFFERENT LANGUAGE

Hank Willis Thomas & Malcolm Jenkins

Hank Willis Thomas: Could you describe an early art-related memory?
Malcolm Jenkins: One of my aunts is an artist—Cynthia Vaughn—and I grew up seeing her paintings all over the house. I started out collecting her work and that of a few other artists based on the limited knowledge I had. She's how I got introduced to Ernie Barnes's work, because she used to practice by re-creating his paintings.

I didn't get really serious about collecting until about a year and a half ago, after I retired from the NFL. Since then I've started going to a lot of shows and meeting artists, and I've been thinking about the ways the art world business model is similar to that of the sports world. I see artists navigating galleries and museums the same way athletes are navigating agents and universities and institutions. It's been interesting to me to see those parallels. Of course, it's different in sports because there's less focus on an athlete's mind and identity. You realize the whole world recognizes you mainly for your body and what you can do with it.

I thought about this the first time I saw your work, in the exhibition *30 Americans* at the Barnes Foundation in Philly. There has been so much conversation about Black athletes and the legacy of slavery. The way your work addresses this is really strong, because you make connections between the athlete's body, identity, and the whole idea of endorsement: how there is often a disregard of athletes' minds in order to focus on branding their bodies, to the point where they almost start to lose ownership over themselves.

HWT: I've been reading a book called *Michael Jordan and the New Global Capitalism*, and it talks about how all of these transnational corporations built their global presence around his star power. And I started thinking about how someone of his stature, from where he was from, might've been treated if he'd been born just fifty years earlier. And that got me thinking about the legacy of lynching, and how slaves were branded as a sign of ownership. And today we're in this media and marketing age where most of what we know about ourselves or share about ourselves is connected to a brand identity, whether it's the car we drive or the shoes we wear or the phone we use.

I've also been thinking about how the idea of success for so many of us Black men, especially when Jordan was coming up, was chained to achievement through sports and entertainment. As I've grown older I've thought a lot about the Underground Railroad, and the ways in which Black bodies were able to use certain signals to find their way north when they were trying to escape. And that got me thinking about the jerseys that you all wear.

When someone buys your jersey, they're attempting to walk in your shoes. And for the generations of athletes, especially after 1970, that were able to find some level of economic freedom for themselves and their families, the way forward was through sports. So yes, you can think about sports and the legacy of slavery, but that might actually look like using one's body and creativity and mind to find liberation.

MJ: I see that a lot in your work—that you control what parts of the image we interact with. I think it's really powerful.

I see artists navigating galleries and museums the same way athletes are navigating agents and universities and institutions. —Malcolm Jenkins

HWT: Thank you. I'm curious to hear more about what you think of Ernie Barnes and the way that he used movement. Do you have his work in your collection?

MJ: Yeah, I do. I was lucky enough to get a piece from his last show in LA. It was a study on paper he did for a large-scale work called *Victory in Overtime*. The painting was commissioned by one of Ernie's former NFL teammates. He eventually became the first owner of an expansion team, the Carolina Panthers, and he wanted something to go in his office.

I was always known for having long arms, and I'm aware of the advantage that gives you as a defender, as an athlete. Ernie's figures have those kinds of elongated limbs and features that are distinctly Black. They're in environments that are distinctly Black, and there's a sense of movement, drama, and also grace in the way that they perform. I see that every time I look at Ernie's work.

HWT: Mm-hmm. I see that too. I think he's one of those artists whose work was so popular that people didn't even really consider it as art. It's exciting to see how appreciation of his work has grown, especially over the past fifteen years. It's the story of an artist, a person, who was so ambitious and so multifaceted, and who achieved success in various fields at a time when so few people with his background did. And I guess, no offense to you or me, I don't think either of us will reach that level of impact, not anytime soon at least.

MJ: Yeah. I find myself being inspired by Ernie right now, having just retired from the NFL and turned my gaze to the art space, like he did, and feeling like a rookie again. He's one of those gold standards for me when thinking about life outside of sports and being great at something other than football. There are not many examples for making that transition.

In general, retired athletes stay around their sport, maybe getting into coaching or commentating. To enter a whole different field is a little bit nerve-racking. But as I spend time with artists, they seem to be very similar to athletes in many ways. They've had to be introspective, to be in their own head and in their own discipline. But also, they are on stage, and have to be able to talk about their work. And it's the same with athletes. You can watch what happens in the game, but if you really want to know what was driving the players, what they were working on, what they were experimenting with, what was happening in their life, you have to talk to them directly.

HWT: What I love about art is the way it can challenge viewers to question their reality and their values, and in a way reconfigure what they know to be true.

I think part of my responsibility as an artist is to create work that is accessible, and I use sports as a tool to do that. I use sports metaphors and sports jerseys and sports stories, but with fine art as my medium. I'm ultimately hoping to present underexplored elements of history or human creativity in a new light.

MJ: Yeah, that's difficult to do. I just wrote a memoir about my career, and it's like, how do you tell a story about events that everyone's witnessed? How do I write about a Super Bowl, the most-watched event on television, and represent it in a way that makes you see something in it that you hadn't seen before?

The reason I love art so much is that it can get you to a different language, or let you attack an issue from a different vantage point. Art can make people challenge themselves, almost like looking into a mirror, and push them to question how they see the world. I'm interested in this because being an athlete is very much a voyeuristic relationship where everyone comes, watches what we do, and then makes sense of it themselves. And we just show up and do it again next week. But art really asks you to sit with it, take it in, see yourself through how you engage with it, and then have a dialogue around that.

★

Malcolm Jenkins is a former professional American football player who was a safety for thirteen seasons in the NFL. He is also a racial-justice advocate, entrepreneur, author, philanthropist, and art collector.

Hank Willis Thomas is a conceptual artist based in Brooklyn who works primarily with themes related to identity, history, and popular culture. In 2023, with the support of Jenkins and other players, Thomas was commissioned by the NFL to create a public sculpture that debuted at Super Bowl LVII.

Part of my responsibility as an artist is to create work that is accessible, and I use sports as a tool to do that.
—Hank Willis Thomas

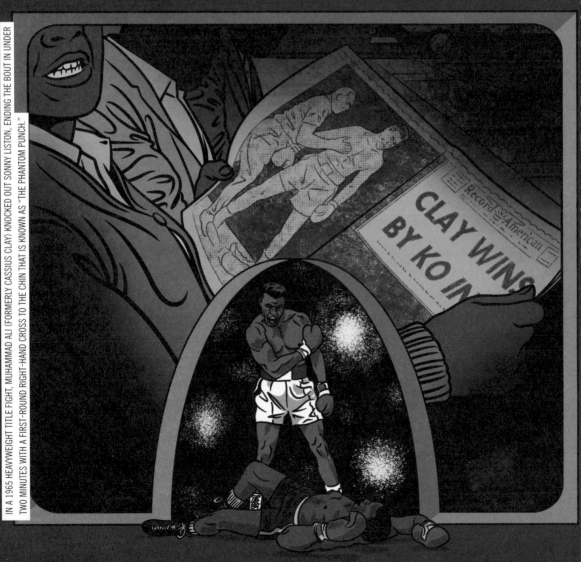

IN A 1965 HEAVYWEIGHT TITLE FIGHT, MUHAMMAD ALI (FORMERLY CASSIUS CLAY) KNOCKED OUT SONNY LISTON, ENDING THE BOUT IN UNDER TWO MINUTES WITH A FIRST-ROUND RIGHT-HAND CROSS TO THE CHIN THAT IS KNOWN AS "THE PHANTOM PUNCH."

AFTERWORD

ON MAY 25, 1965, *Sports Illustrated* photographer Neil Leifer shot one of the most iconic photos in sport history. It documents the aftermath of a punch that almost no one ringside actually saw land. Just one minute and forty-four seconds into the first round, heavyweight boxing champion Muhammad Ali felled the legendary Sonny Liston, the man he'd snatched the title from in a bout the previous year. Audiences were outraged—the heavily favored Liston had never been knocked out before. Leifer's ubiquitous photo of Ali, framed by powerful overhead lights and thick clouds of cigar smoke, shows the boxer radiating the brawn and poetic bravado that made him both so beloved and so widely reviled in the 1960s, an era of seismic shifts in American culture. Ali, who was a phenomenal athlete as well as an advocate for racial justice and an outspoken critic of the Vietnam War, bridged the worlds of sport, politics, activism, and pop culture in profound and previously unimaginable ways. Ali's legacy informs a core belief that has guided the development of *Get in the Game*: namely, that there is great insight and inspiration to be gained from bringing together sport as a cultural phenomenon and art as a field of inquiry—two realms where a separation persists in the collective imagination—and critically examining their messy intersections.

Get in the Game: Sports, Art, Culture began to take form shortly after I started my tenure as Helen and Charles Schwab Director of SFMOMA in 2022, and it is a project that is both aligned with the museum's strategic priorities and uniquely personal for me. It marks an evolution in my career-long investment in art and its

relationship to sport, something I've explored in various smaller exhibitions over the years, including *Hard Targets—Masculinity and Sport* (2008) at the Los Angeles County Museum of Art and *Mixed Signals: Artists Consider Masculinity in Sports* (2010) at the Wexner Center for the Arts. My view of sport as a subject within art history that holds a unique purchase on the public consciousness began to develop when I was a student at Oberlin College. I had gone to Oberlin with the intention of being a swimmer and studying English literature. I was soon totally seduced by American football as well as art, and ended up playing defensive tackle for the Oberlin Yeomen and majoring in art history. Having the privilege to learn from the objects in the university art museum rather than solely from textbooks was a powerful experience that opened my eyes to the potential of the museum as classroom—a space that brings ideas alive, creating a bridge between higher learning and everyday experience. As a college athlete I discovered Matthew Barney (also a football player), an artist whose involvement in sport served as a starting point for his work, and I began thinking in new ways. The bringing together of academics and athletics, museum and stadium, decisively focused my lens on the world.

I firmly believe that in leveraging the far-reaching appeal of sport as a cultural touchstone, *Get in the Game* presents a similar opportunity for a broad audience to be engaged experts, actively participating in rethinking how the widely familiar realm of sport operates in contemporary culture and their own lives. Such generosity of address is central to this institution's ongoing efforts to expand our reach and make equity-centered, research-driven art history accessible to the widest public imaginable. This multifaceted project encompasses a series of exhibition spaces across the museum; a range of educational and public programs organized in collaboration with scholars, artists, designers, writers, and athletes; and of course the stunning publication you now hold in your hands, which in its scope, format, and range of voices could not be farther from a typical museum catalogue. I commend co-curators Jennifer Dunlop Fletcher, Seph Rodney, and Katy Siegel for their tremendous efforts in bringing together every aspect of this complex and groundbreaking endeavor. I also applaud guest curators Jeffrey Cheung and Gabriel Ramirez of Unity, along with SFMOMA Assistant Curator of Media Arts Tanya Zimbardo, for their stellar work on related presentations that will be on view concurrently with *Get in the Game*. Profound gratitude is due to Gamynne Guillotte and

her team in Education and Community Engagement for piloting a fresh approach to interpretation within the exhibition and bringing an engaging suite of related programs and events to life. I join the curators in thanking all of the museum staff members named on pages 159–61—this was a true team effort. We are gratified that following the San Francisco presentation, the exhibition will reach an even wider audience. As of our publication date, *Get in the Game* is confirmed to travel to Crystal Bridges Museum of American Art in Bentonville, Arkansas, and to Pérez Art Museum Miami. We are delighted to partner with both institutions.

An undertaking such as this would not be possible without the generosity of our steadfast community of sponsors and donors. Lead support for *Get in the Game* is provided by Bank of America. Presenting support is provided by Dana and Bob Emery. Major support is provided by KHR McNeely Family Fund and Mary Jo and Dick Kovacevich. Significant support is provided by Mary Jane Elmore, Susan Karp and Paul Haahr, Jessica Moment, Nancy and Alan Schatzberg, and anonymous. Meaningful support is provided by Ethan Beard and Wayee Chu and Maryellen and Frank Herringer. On behalf of the entire museum staff I thank you for enabling us to mount this ambitious project and further our ongoing efforts to create an open space where diverse perspectives and meaningful conversations can flourish.

Christopher Bedford is the Helen and Charles Schwab Director of the San Francisco Museum of Modern Art (SFMOMA). He previously served as the Dorothy Wagner Wallis Director of the Baltimore Museum of Art (2016–22) and was Commissioner of Mark Bradford's presentation in the American Pavilion at the 2017 Venice Biennale.

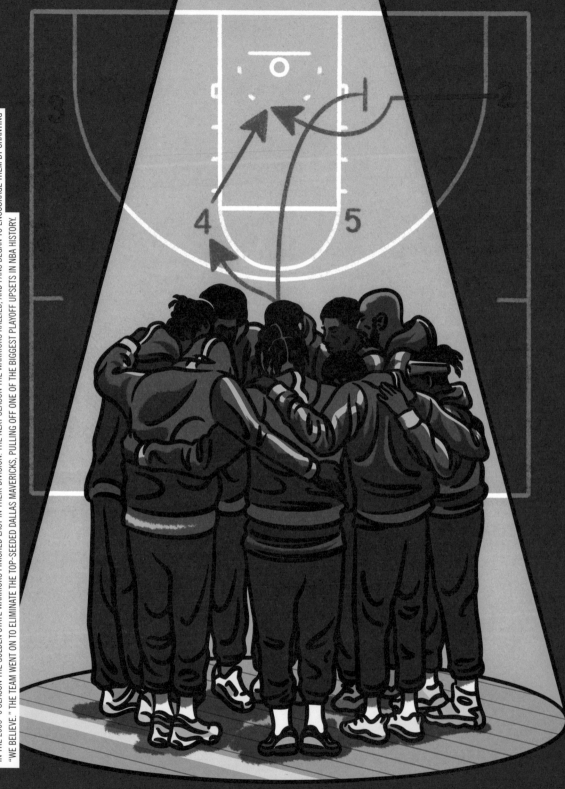

IN THE 2005–6 SEASON THE GOLDEN STATE WARRIORS FINISHED LAST IN THEIR DIVISION. THE NEXT SEASON THE WARRIORS RALLIED, AND FANS BEGAN TO ENCOURAGE THEM BY CHANTING "WE BELIEVE." THE TEAM WENT ON TO ELIMINATE THE TOP-SEEDED DALLAS MAVERICKS, PULLING OFF ONE OF THE BIGGEST PLAYOFF UPSETS IN NBA HISTORY.

ACKNOWLEDGMENTS

TO SAY THIS PROJECT WAS A TEAM EFFORT is an understatement. From our earliest planning conversations we focused on expanding our thinking around the audiences an art museum might engage, and also sought to broaden the number of staff creatively involved in developing and executing every aspect of this endeavor. The former and current athletes, superfans, and sports enthusiasts among our ranks responded with gusto to our call to get in the game, contributing their expertise and hard work in many ways as we ventured into new territory with this exhibition and publication and the related installations and programming.

In the lead-up to opening day, deep research informed our work at every stage. The team that investigated the intersecting histories of sports, art, and culture and shaped our knowledge of and across those fields includes veteran players Jenny Dally, Amara Lawson-Chavanu, Daryl McCurdy, and Gabriella Shypula; rookies Charlene Wichaidit and Gavin Trotmore; and recent draft picks Hyoeun Kim and Ann Tartsinis. Special thanks go to team manager (and artist, athlete, and fan) Adrian Martinez, who shared his encyclopedic knowledge of sports and kept us all on track. Among the many talent scouts outside the museum who offered advice and feedback are Dave Zirin, Larry Ossei-Mensah, Steven Connor, Kelvin Beachum, Troy Vincent, Megan Rapinoe, Tabitha Soren and Michael Lewis, and Glenn Kaino. We thank the great Harry Edwards, a giant in the field of sports history, for granting us permission to quote him in the book's epigraph.

We are deeply indebted to the stellar lineup of contributors to this book, who brilliantly expressed the insights gained from lifelong engagement in their fields. Many thanks go to the artists, athletes, and cultural figures paired in dialogue: Mario Ayala and Leo Fitzpatrick; Patricio Manuel and Meg Onli; Alysia Montaño, Jane Gottesman, and Evelyn C. White; Catherine Opie and Diana Nyad; Ronny Quevedo and Nelson Peñaherrera; Felandus Thames and Elliot Perry; Hank Willis Thomas and Malcolm Jenkins; Cheresse Thornhill-Goldson and Dr. D'Wayne Edwards; and Susie Wolff and David Sze. We are grateful to Natalie Diaz for granting us permission to reprint her beautiful

poem. Thanks also go to Megan Rapinoe for her thoughtful and inspiring foreword and to the cleanup hitters who wrote such incisive and engaging essays: Frank Andre Guridy, Sara Hendren, Jay Caspian Kang, Theresa Runstedtler, and Bruce Schoenfeld.

We wanted this book to pack the emotional, physical, and aesthetic punch of a great sports match. We were extremely fortunate to work with artist and surfer AJ Dungo, whose powerful and exuberant illustrations of iconic moments in sports history create the distinctive visual world contained in these pages. Designer (and baseball fanatic) Bob Aufuldish brought expertise and equanimity to our effort to produce a museum publication that is atypical in many ways. Our undying gratitude goes to the MVP of this publication (and coach to all of us) Amanda Glesmann, whose detailed gameplays and motivating humor are legendary. Third-generation Red Sox fan Jennifer Boynton brought unrivaled care and a sporting spirit to all phases of editing and proofreading. Clutch players Kari Dahlgren and Clare Jacobson offered editorial support at key moments along the way. We are thrilled to be teaming up with Ilona Oppenheim and her colleagues at Tra Publishing in a co-publishing partnership that will bring this book to a wide audience beyond the museum's walls. Debbie Bibo provided key guidance as we developed the publication's concept and approach. Southern California cycling legend Tony Manzella and his team at Echelon Color brought the hurt throughout the color separation process, going beast mode to make sure every image looks its best. Zeno Ferrandini, Mari Perina, Nancy Freeman, and their colleagues at Verona Libri left it all on the field during the printing and binding of this volume.

The work of the artists and designers featured in the exhibition this book accompanies has been an inspiration and touchstone for us throughout the project. We thank: Virgil Abloh, Otl Aicher, Michael Alvarez, Emma Amos, K. Anderson, Eric Arakawa, Iwan Baan, Ernie Barnes, Matthew Barney, Holly Bass, Kevin Beasley, Günter Behnisch and Frei Otto, Willie Birch, Andrea Bowers, Mark Bradford, Thom Browne, Zoë Buckman, Miguel Calderón, Alejandra Carles-Tolra, Ryan James Caruthers, Maurizio Cattelan, Kevin Chu, Brad Cracchiola and Designworks, Martin Creed, Karla Diaz, Omar Victor Diop, Rosalyn Drexler, Celeste Dupuy-Spencer, Buck Ellison, Cara Erskine, Kota Ezawa, Derek Fordjour, Samuel Fosso, Sam Fresquez, Fred Gehrke, Jeffrey Gibson, Douglas Gordon and Philippe Parreno, Daniel Green, Lourdes Grobet, Sko Habibi, Chase Hall, David Hammons, Hugh Hayden, Danny Hess, Reggie Burrows Hodges, Gary Hustwit and Jon Pack, Mark Igloliorte, Cameron Jamie, Michael Jang, Clotilde Jiménez, Brian Jungen, Titus Kaphar, Martin Kazanietz, Christine Sun Kim, Savanah Leaf, Cary Leibowitz, Shaun Leonardo, Glenn Ligon and Byron Kim, Yolanda López, Jérémy Lucas, Roberto Lugo, Katrina Majkut, Tara Mateik, Sam McKinniss, Lucy McRae, Julie Mehretu, Esmaa Mohamoud, Thenjiwe Niki Nkosi, Juan Obando, Betsy Odom, Catherine Opie, Oracle Racing, Gabriel Orozco, Goo Choki Par, Anna Park, Grace Rosario Perkins, Paul Pfeiffer, Cheryl Pope, Robert Pruitt, Ronny Quevedo, Deborah Roberts, Sheena Rose, Yara Said, Ben Sakoguchi, Ivan Salcido, Bárbara Sánchez-Kane, Nicholas Schonberger and Nike, William Scott, Joan Semmel, Jean Shin, Yinka Shonibare, Bob Simmons, Gary Simmons, Tabitha Soren, Brit Stakston and Martin Schibbye at Blankspot, Tavares Strachan, Matt Tanner and McLaren Racing, Ashley Teamer, Eduardo Terrazas, Felandus Thames, Hank Willis Thomas, Jake Troyli, Martin Wong, Lance Wyman and Bill Cannan, Yoshiro Yamashita, and Tokujin Yoshioka. We are also grateful to all those featured in Unity through Skateboarding: Raisa Abal, Anthony Acosta, Felix Adler, Mario Ayala, Taylor Ballard, Joe Brook, Michael Burnett, JP Calubaquib, Sean Carabarin, Allan Carvalho, Jonathan Lyndon Chase, Jeffrey Cheung, Justin Ching, Rey Choto, Ben Colen, Rob Coons, Mark Custer, Lori Damiano, Dylan Doubt, Matt Fookes, Vivian Fu, James Givens, Bryce Golder, Corey Greengage, Peter Gunn, Joe Hammeke, Theo Hand, Koji Harmon, Tristan Henry, Greg Holland, Florian "Burny" Hopfensperger, Norma Ibarra, Mike Iemma, Atiba Jefferson, G.B. Jones, Andrew Judd, Bryce Kanights, Margaret Kilgallen, Briana King, Henry Kingsford, Andrew Li, Reece Leung, Mae Ross, Marbie, Marc Matis, Alicia McCarthy, Keegan McCutchen, Sam McGuire, Sarah Meurle, Uine Monteiro, Gabe Morford, Diana Musa, Ted Newsome, Reanna Norman-Irei, Avery Norman, Luke Ogden,

Stephen Nestor Ostrowski, Alex Papke, Grant Payne, Matt Pendry, Matt Price, Brontez Purnell, Gabriel Ramirez, Giovanni Reda, Fabi Reichenbach, Aram Sabbah, Alexis Sablone, Diego Sarmento, Kyle Seidler, Sabrina Sellers, Ryan Shorosky, Miriam Klein Stahl, Josh Stewart, Cher Strauberry, Zander Taketomo, Abi Teixeira, Deanna Templeton, Ed Templeton, Kevin Thatcher, Bill Thomas, Nam-Chi Van, Marcel Veldman, Elska von Hatzfeldt, Brent Waterwort, Lisa Whitaker, Alex White, Rich Whitehead, and Zane York.

Bringing together their work in exhibition spaces spanning the museum required exceptional team spirit and drive. We are grateful to fuseproject, the San Francisco–based design firm led by Yves Béhar, for collaborating with us to design an exhibition experience that feels dynamic, multisensory, and at times interactive. Executing this complex undertaking would not have been possible without the steady hands of Chief Collections, Exhibitions, and Design Officer Dee Minnite, who took over leadership mid-game from Tsugumi Maki. In Exhibitions and Program Management, David Funk, along with Paul Armstrong, Angelo Hallinan, and Angie Wilson, refereed the entire project, keeping cool heads and considering all angles before making a call. We are hugely indebted to exhibition designer Fernanda Carlovich for her beautiful work on the in-house aspects of the design effort, and for her enormous capacity for creative problem-solving. We extend sincere gratitude to Claire LaMont, Martin Malvar, and the installation and exhibitions technical teams, including Brian Caraway, Steve Dye, John Davis, Brandon Larson, Sylvie Sutton, and Brian Weinstein. In Registration, thanks are due to Maren Jones, Andrew Haller, and Jennifer Hing. Michelle Barger, Jennifer Hickey, and their colleagues in Conservation rallied together to care for the works in the exhibition. Gamynne Guillotte, Chief Education and Public Engagement Officer, dove headlong into the project after arriving at SFMOMA last year, quickly becoming an important thought partner and laying the groundwork to marshal visitor engagement. She received key assists from seasoned competitors in Interpretive Media, Education, and Public Engagement: Erica Gangsei, Kevin Carr, Julie Charles, Kathleen Maguire, and Tomoko Kanamitsu. Director of Partnerships Suzy Varadi and her team deftly kept the ball alive with external partners throughout the project. In Philanthropy, thanks go to Alison Bowman and Margaret Coad for keeping the box seats warm with enthusiastic supporters, and to Daniel Johnson and Jennifer Mewha for teeing up and closing out important grant applications. We passed the ball and are indebted to guest curators Unity (Jeffrey Cheung and Gabriel Ramirez); Assistant Curator of Media Arts Tanya Zimbardo for her project with Jenifer Wofford; Curator and Head of Photography (and avid basketball fan) Erin O'Toole for her counsel on photography; and colleagues across the SFMOMA curatorial division for their armchair quarterbacking. Chief Experience Officer Sheila Shin and colleagues in Marketing and Communications Clara Hatcher Baruth, Alexandra Nguy, Océane Qui, Cristina Chan, Claire Bradley, Colin Howard, Julie Lamb, and Andrea Wang, in partnership with Alina Sumajin of PAVE Communications and Consulting, not only spread the word but also deepened the meaning of the project through partnerships and community connections. We could not have made it across the finish line without the efforts of Naheed Simjee in the Director's Office; Bosco Hernández and Caroline Holley in the Design Studio; Nicole Meshack, Brianna Jilson, Ric Weaver, Darcie Oyama, Corey Brady, Jordan Nickels, Sherri Carey, and the Visitor Experience staff; Sriba Kwadjovie Quintana in Archives and Art Resources; Shane Salvata, Anne-Marie Conde, and Tobey Martin in the Museum Store; Anna Tang and Nahshon Clark and their colleagues in Finance; Walter Coupland and his Security team; and David Dial, Courtney Costello, Walter Logue, and Tim Tengonciang in Operations. Finally, thanks to Helen and Charles Schwab Director of SFMOMA Chris Bedford, a retired rugby star, American footballer, and all-around fan, for throwing out the first pitch.

This project stretched all of us, and we are most grateful for our pep talks with close family and dear friends who cheered us on from the sidelines and shared with us in underdog upsets, shocking trades, and playoff magic.

Jennifer Dunlop Fletcher, Seph Rodney, & Katy Siegel

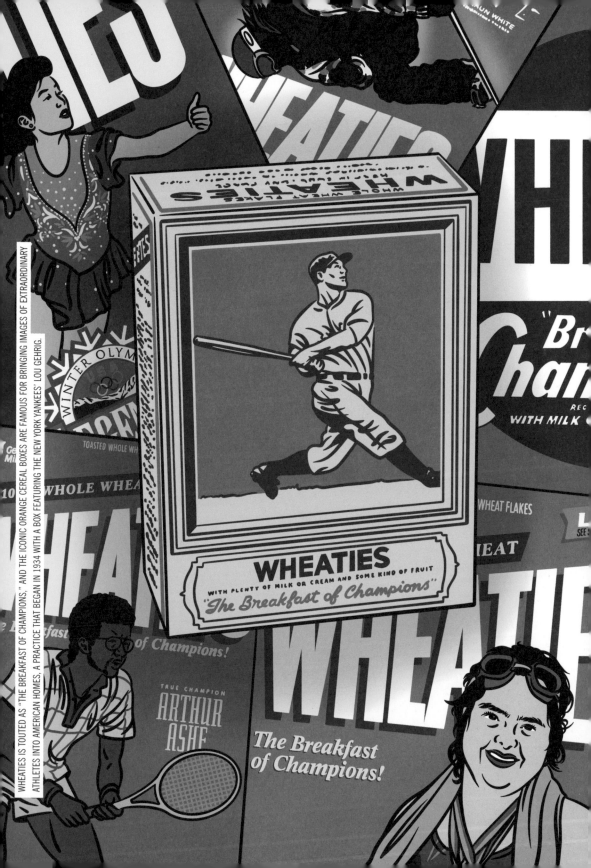

WHEATIES IS TOUTED AS "THE BREAKFAST OF CHAMPIONS," AND THE ICONIC ORANGE CEREAL BOXES ARE FAMOUS FOR BRINGING IMAGES OF EXTRAORDINARY ATHLETES INTO AMERICAN HOMES, A PRACTICE THAT BEGAN IN 1934 WITH A BOX FEATURING THE NEW YORK YANKEES' LOU GEHRIG.

ESSAYISTS

Jennifer Dunlop Fletcher is Helen Hilton Raiser Curator of Architecture and Design at the San Francisco Museum of Modern Art. Her recent curatorial projects include *Nature x Humanity: Oxman Architects* (2022) and *The Sea Ranch: Architecture, Environment, Idealism* (2018). Since 2010, she has been building SFMOMA's Architecture and Design collection with an emphasis on experimental works of design since 1980.

Frank Andre Guridy is an award-winning historian and a professor of history and African American studies, and the executive director of the Eric H. Holder, Jr. Initiative for Civil and Political Rights at Columbia University, New York. He is the author of *The Stadium: An American History of Politics, Protest, and Play* (Basic Books, 2024).

Sara Hendren is an artist, writer, design researcher, and professor at Northeastern University, Boston. In art and design works, journalism, criticism, and commentary, she addresses the intersections between disability and design, raising questions about their most enduring themes: ability, capacity, dignity, suffering, and the assisted body across the life span.

Jay Caspian Kang is an American writer, editor, television journalist, and podcast host. He is a staff writer at the *New York Times Magazine* and the Opinion section of the *New York Times*. Previously he was an editor of *Grantland*, then of the science and technology blog Elements at *The New Yorker*.

Seph Rodney, PhD, is a former senior critic and opinions editor for Hyperallergic and is now a regular contributor to the *New York Times*. His book, *The Personalization of the Museum Visit*, was published by Routledge in May 2019. In 2020 he won the Rabkin Prize for Arts Journalism and in 2022 he won an Andy Warhol Foundation Arts Writers Grant. He lives and works in Newburgh, New York.

Theresa Runstedtler is a scholar of African American history and sports studies at American University, Washington, DC. She is the author of *Black Ball: Kareem Abdul-Jabbar, Spencer Haywood, and the Generation that Saved the Soul of the NBA* (2023) and *Jack Johnson, Rebel Sojourner: Boxing in the Shadow of the Global Color Line* (2012).

Bruce Schoenfeld has written about the commercial side of sports for *GQ*, the *New York Times Magazine*, and ESPN. He continues to write regularly for the *Sports Business Journal*, which hired him as its first columnist in 1998, and is the author of *Game of Edges: The Analytics Revolution and the Future of Professional Sports* (2023).

Katy Siegel is Research Director, Special Program Initiatives, at the San Francisco Museum of Modern Art. Her recent curatorial projects include *Joan Mitchell* (2021), *Odyssey: Jack Whitten Sculpture, 1963-2017* (2018), and Mark Bradford's presentation in the American Pavilion at the 2017 Venice Biennale. She is a Distinguished Professor at Stony Brook University (SUNY), and serves on the advisory committee for the African American Archive Initiative at the Getty Research Institute.

This book is published on the occasion of the exhibition *Get in the Game: Sports, Art, Culture*, co-curated by Jennifer Dunlop Fletcher, Seph Rodney, and Katy Siegel, and organized by the San Francisco Museum of Modern Art.

Lead support for *Get in the Game* is provided by Bank of America.

BANK OF AMERICA 〰〰

Presenting support is provided by Dana and Bob Emery.

Major support is provided by KHR McNeely Family Fund and Mary Jo and Dick Kovacevich.

Significant support is provided by Mary Jane Elmore, Susan Karp and Paul Haahr, Jessica Moment, Nancy and Alan Schatzberg, and anonymous.

Meaningful support is provided by Ethan Beard and Wayee Chu and Maryellen and Frank Herringer.

This book was produced by the publications department at the San Francisco Museum of Modern Art (Kari Dahlgren, director of publications; Amanda Glesmann, managing editor; Clare Jacobson and Brianna Nelson, editors; Jessica Sevey, assistant editor).

Project editor: Amanda Glesmann
Editor: Jennifer Boynton
Designer: Bob Aufuldish, Aufuldish & Warinner
Illustrator: AJ Dungo

Color separations by Echelon, Los Angeles
Printed in Italy by Verona Libri

Library of Congress Control Number: 2024936171
ISBN 978-1-962098-03-8
10 9 8 7 6 5 4 3 2 1

San Francisco Museum of Modern Art
151 Third Street
San Francisco, California, 94103
sfmoma.org

Published in association with
Tra Publishing
245 NE 37th Street
Miami, FL 33137
trapublishing.com